# NORTHALLERTON
## THROUGH TIME

Paul Chrystal &
Mark Sunderland

AMBERLEY PUBLISHING

# Acknowledgements

Thanks go to James Lake, Rocastle Books for many of the pictures of Northallerton; to Sarah McKee, Community Projects Officer, Bettys & Taylors of Harrogate for the photograph on p. 33; the staff at Northallerton railway station; Sion Hill; Swinton Park; Black Sheep Breweries, Masham for the photographs on p. 95 and 96; Sir John Ropner, Thorp Perrow; Ripon Workhouse Museum; the staff at Northallerton Reference Library. Rick Harrison for the Masham Sheep Fair photo on p. 92 www.fortybelowzero.com

Paul Chrystal and Mark Sunderland are authors of these other titles in the *Through Time* series:
*Knaresborough; North York Moors; Tadcaster; Villages Around York; Richmond*

Paul Chrystal and Simon Crossley are authors of the following forthcoming titles in the series:
*Harrogate; Hartlepool; Vale of York; Redcar, Marske and Saltburn*

More of Mark Sunderland's work can be found at www.marksunderland.com
For more books on Yorkshire go to www.knaresboroughbookshop.com

*for Anne, Rachael, Michael and Rebecca*

First published 2010

Amberley Publishing
Cirencester Road, Chalford,
Stroud, Gloucestershire, GL6 8PE

www.amberleybooks.com

Copyright © Paul Chrystal & Mark Sunderland, 2010

The right of Paul Chrystal & Mark Sunderland to be identified as the Authors of this work has been asserted in accordance with the Copyrights, Designs and Patents Act 1988.

ISBN 978-1-84868-8181-1

British Library Cataloguing in Publication Data. A catalogue record for this book is available from the British Library.

Typeset in 9.5pt on 12pt Celeste.
Typesetting by Amberley Publishing.
Printed in the UK.

# Introduction

Many photographic books have been published in recent years showing Northallerton as it was at the end of the nineteenth and in the early years of the twentieth century; none of these, however, has juxtaposed the old pictures with 2010 equivalents to demonstrate how far things have changed, or not as the case may be. *Northallerton Through Time* does just that: it is a unique collection of 180 photographs showing the old and the new, supported by incisive and informative captions.

And it is a fascinating story – beginning with the twelfth century rout of the Scots at the Battle of the Standard then taking us through 700 years which saw the town develop as a major stop on the road from London to Edinburgh – not least for marauding Scots and Edwards I, II and III at the head of their armies; later monarchs followed. This road was to become the Great North Road running through Northallerton with its attendant coaching inns. The York to Darlington main railway line brought with it more change and helped new local industries – linen, dairy and linoleum – to develop and prosper. Two hospitals, the Cottage or Rutson and the Friarage have been central to life here although St James' predates them by more than 750 years; the demolition of the yards in the 1950s and 1960s and the re-housing of many of the town's inhabitants was a major social development.   Finally, from eighteenth-century beginnings which included the Registry of Deeds, the County Court House and Gaol, the last century also saw the town established as the major administrative centre for the North Riding and latterly North Yorkshire.

Down the years commentators have emphasized the importance of the High Street:  William Camden's 1586 *"Northallerton...which is nothing but a long street"* echoes John Leland's 1538  *"The Towne of Northalverton is yn one fair long Streate lying by South and North".* Both implicitly recognise its arterial function – on and from the High Street all Northallerton life flows:  shops, businesses, markets, houses,

church, hospital, school, pubs, people – all at one time or another have existed on or very close to that "*fair long Streate*". All of that life, commerce and society is captured here in pictures and in words.

Nearby villages and towns are covered in the same way. These include Romanby and Brompton and, further afield, Bedale, Masham, Hutton Rudby, Swainby, Osmotherley, South Otterington and Great Smeaton. Fine houses at Mount Grace, Sion Hill, Swinton Park and Thorp Perrow also feature, as does the fascinating Mount Grace Priory itself.

The colour photography is by Mark Sunderland, freelance landscape photographer, who has successfully challenged omnipresent traffic, grey skies, rampant foliage and ugly street furniture to produce a set of vibrant modern images of the highest standard - another battle won.

Paul Chrystal, November 2010

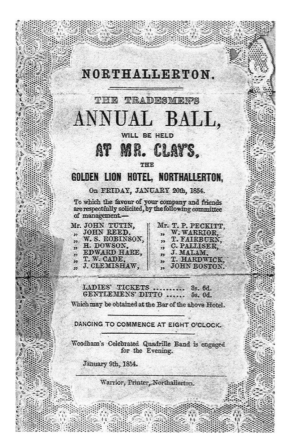

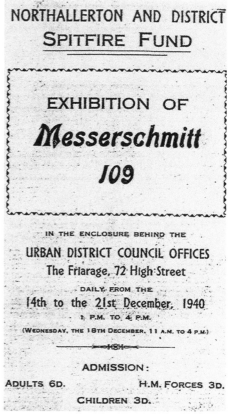

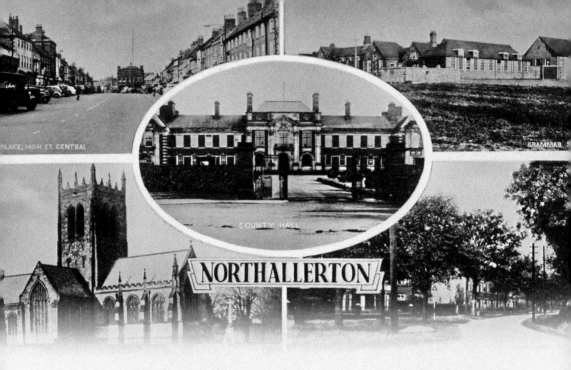

CHAPTER 1

# Northallerton Streets and Roads

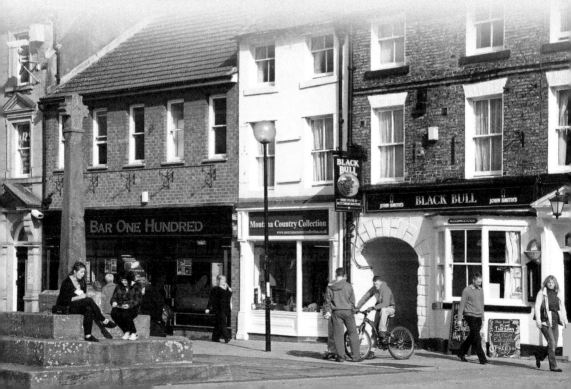

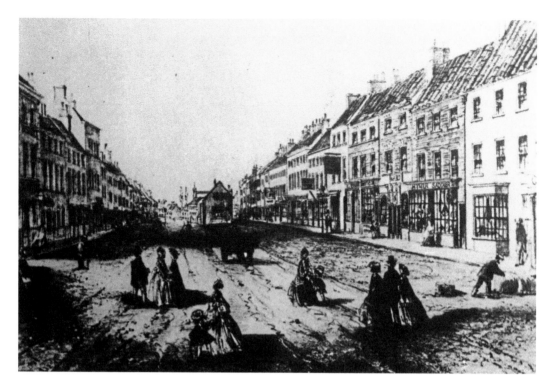

### The High Street

A mid 1800s drawing of Northallerton High Street looking south giving some indication of its length (nearly ½ mile) and broad width ( approximately 15 feet). The shepherd with his sheep on the near right, the well-dressed ladies and gentlemen  and Hymer's saddlers shop mid right give a vivid  impression of daily life then.  The new picture shows how little has changed architecturally along the street although the Tollbooth in the distance has gone.

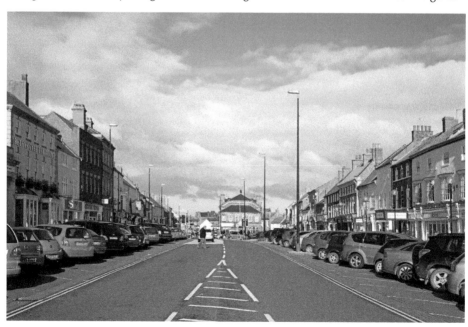

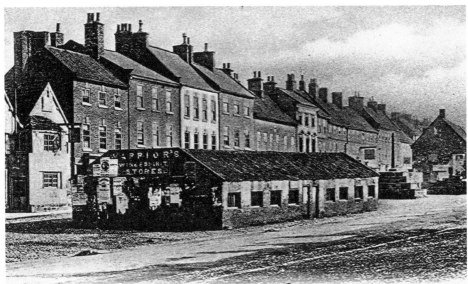

*Old Northallerton. The Shambles and Cross, Main Street.*

### The Shambles and Cross

An 1870 photograph showing the Tollbooth, Market Cross and Shambles three years before the Shambles was demolished to make way for the Town Hall in 1873. The Shambles comprised two rows of slaughter houses, butchers and tanners – the smell there must have been horrendous, and they attracted vermin from nearby Sun Beck. Northallerton Market and Public Improvement Company bought the site from the Ecclesiastical Commissioners and knocked it all down. The Tollbooth was the administrative centre from 1720, replacing the Guild Hall. Six shops traded on the ground floor (one being Warrior's Stores) with the gaol (The Black Hole) above.

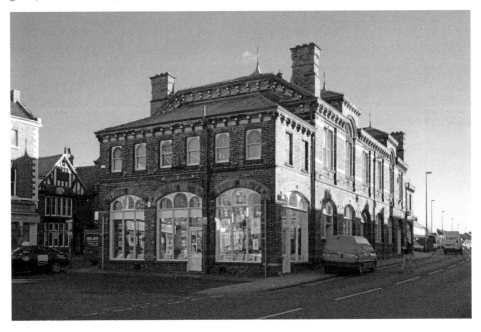

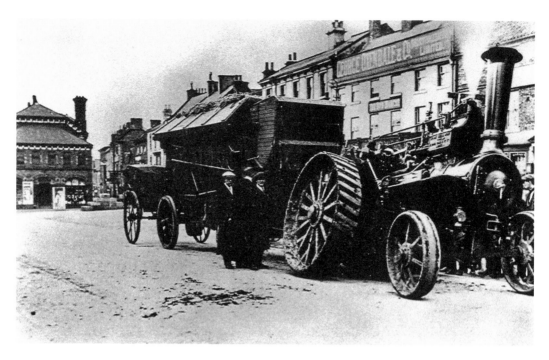

Foden Traction Engine in the High Street

1900 Foden traction steam engine #455 with broken wheel in 1909. It was owned by local engineering company J. Weighell & Sons. Oxendales in the background was run by George Oxendale who later moved to Manchester and ran a highly successful warehousing company. The Town Hall to the left, a famous eyesore, was described by Pevsner as *"irredeemable... ,Joyless, utterly ignorant."*

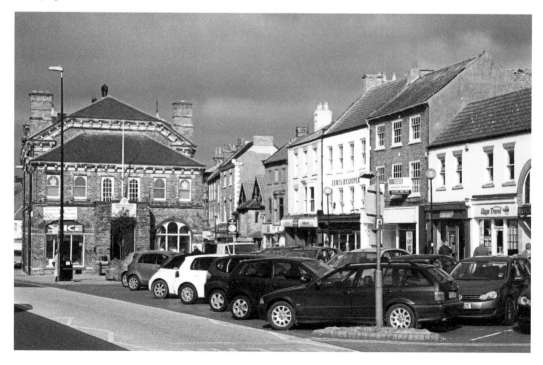

## Tank Traps in the High Street

Erected in 1940 in case of invasion these traps are at the southern end of the High Street; others were situated at the northern end and on the Boroughbridge Road. The traps are gone but a tank block survives on the railway bridge at Castle Hills. The Nag's Head and South End café can be seen on the right.

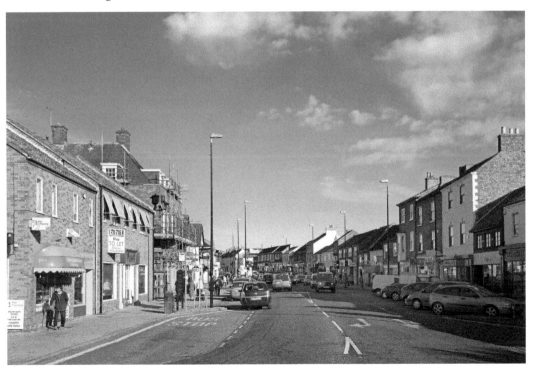

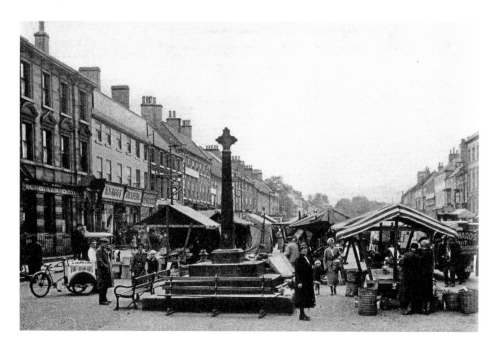

## Wednesday Market

The 1777 cross has led an itinerant life: page 7 shows it close to the Shambles; Percy Hindmarsh bought the Cross for £5.00; it was then bought by John Ingleby Jefferson, Deputy steward of the manor of Northallerton, and removed to his home, Standard House, after the demolition of the Shambles in 1872. Then it was re-sited in its present position in 1913 when the Town Hall was built on the site of the old shambles. The market originates from 1127 when a Wednesday market was granted; this was endorsed in 1772 by the Bishop of Durham along with four fairs: Candelmas (14 February); St Bartholemew's (6 September); St George's (6-7 May) – the original May Fair; St Matthew's cheese fair (6 October). The Wednesday and a Saturday market survive to this day, as the modern picture shows.

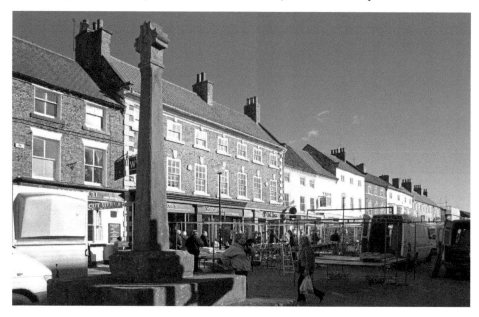

## Black Bull Yard and Demolition

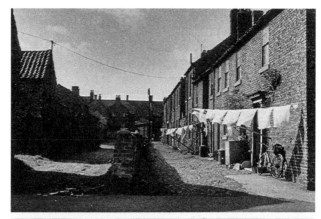

The top photograph shows Black Bull Yard behind The Black Bull Inn, in the early 1950s prior to demolition; the middle photograph a nearby yard being demolished. The yards, or rows, led off to the east and west of the High Street and housed thousands of people in crowded and, until a water and sewage system was introduced, insanitary conditions. In nearby New Row the 1891 census shows 109 people living in 22 houses and in 1851 we know of a man living in one room with his wife and six children. This 1848 report sums it all up: *"Black Swan Yard contains 13 houses, 10 occupied by 43 persons. The fluid excrement flows over the surface of the yard from the 3 privies, open pit and dungstead, and pigsties opposite the doors."*

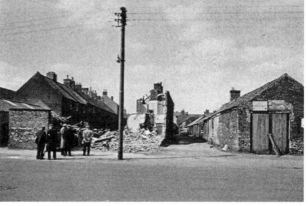

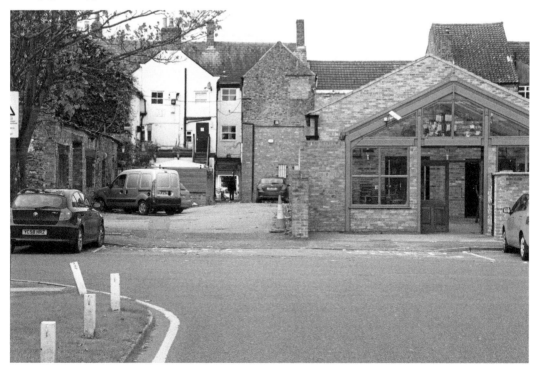

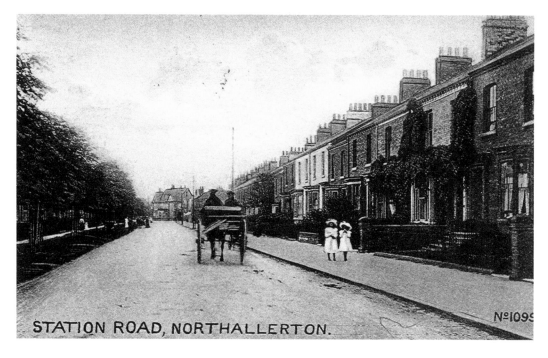

STATION ROAD, NORTHALLERTON.

Nº1099

### Station Road–South Parade

The arrival of the railway led to the development of housing in 1860 down this hitherto houseless street – the first such outside the High Street. The name was later changed to South Parade. The first house was built for a Miles Soppett and by 1890 the street had houses on both sides as this photograph from the 1890s shows. The night of 13 May 1941 saw a German bomber release its load of bombs and incendiaries on County Hall and on the White House in South Parade – since demolished and replaced by Stanley Court. A soldier was killed in the raid. Transport apart, little has changed.

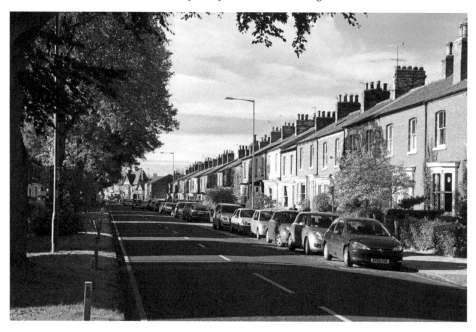

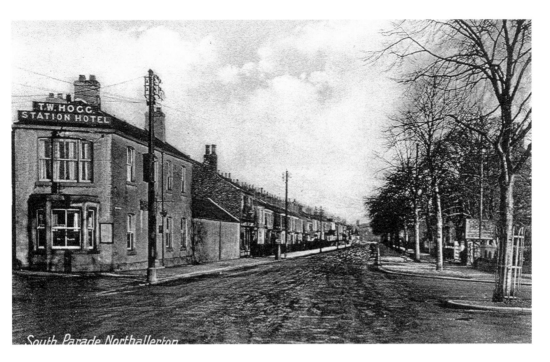

## South Parade

The Station Hotel on the left was, at this time, owned by Tommie Hogg. Soon the name was to change to the North Riding Hotel while The Railway Hotel near to the station changed its name to the Station Hotel. Before all this it was called The Horse and Jockey when Northallerton races still existed. Confused? The County Hotel can just be seen behind the trees on the right; formerly The Temperance Hotel it was eventually bought by North Riding County Council.

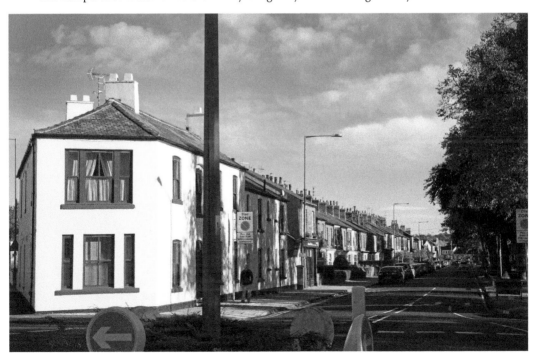

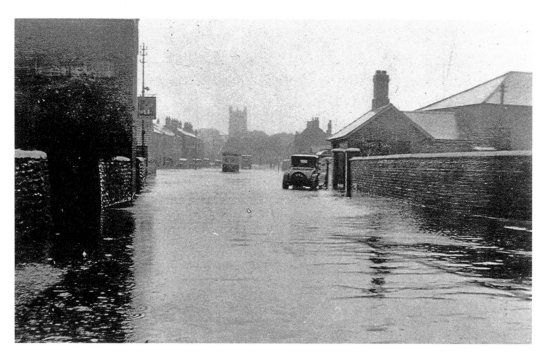

## Flooding at North End

1931 flood waters at North End – a by no means unusual occurrence when Sun Beck and Willow Beck burst their banks. The John Smith owned Railway Hotel can be seen on the left here serving the nearby LNER goods station and the corn mill. The original name for Northallerton was the Saxon Alfhere's tun, or Alfred's farm – indicating an essentially agricultural character.

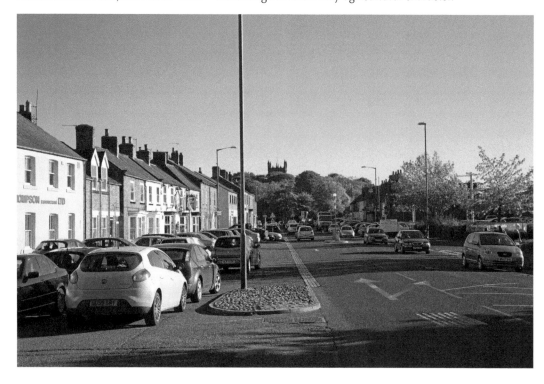

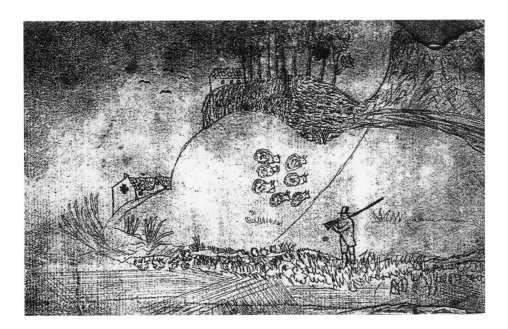

### Castle Hills

This early nineteenth-century drawing shows Castle Hills replete with game. Domesday has Northallerton variously as Alvertune, Aluertune and Alreton and had featured prominently in William I's shocking harrying of the north – scorched earth devastation from Ouse to Tyne in reprisal for the murder of the Earl of Northumberland. Langdale tells us that the sky went black when William's armies arrived – a manifestation of the saint who protected the town and who meted out severe punishment on anyone offering even *"the smallest injury."* William, though, was having none of it and *"laid waste the country on all sides"* – hence the description in Domesday as *"modo wastum est."* The Gentleman's Magazine for February 1844 describes events thus: *"for 60 miles between York and Durham he did not leave a house standing; reducing the whole district by fire and sword to a horrible desert, smoking with blood, and in ashes."*

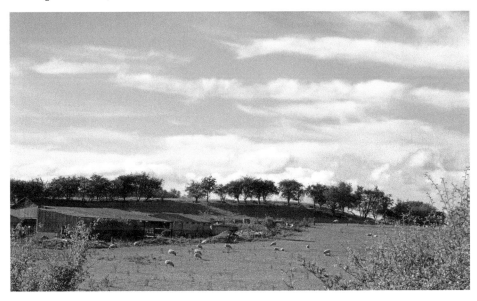

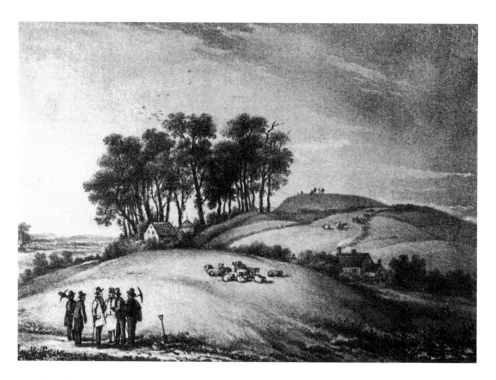

### Castle Hills and the Roman VIth Legion?

An 1838 S. Bendixon print of roughly the same view with what looks like railway surveyors inspecting the land prior to the construction of the Great North of England Railway from Darlington to York. A quarter of a million tons were removed during which Roman artefacts were discovered including a votive altar dedicated to the VIth Legion, coins and a well; all of which lends credence to Roger Gale's thesis in 1739 that a Roman settlement existed here: *"It is highly probable that it [Northallerton] arose out of the ashes of an old Roman station".*

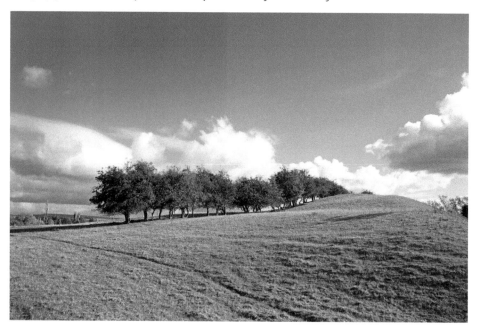

CHAPTER 2

# Northallerton Places
# and Buildings

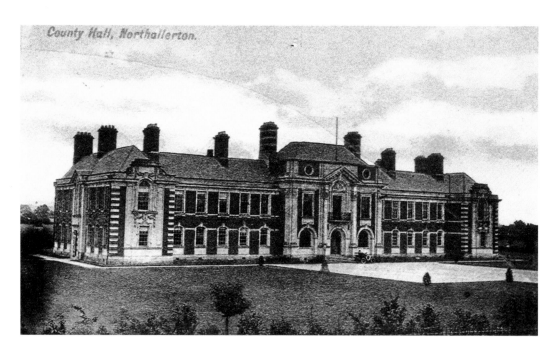

County Hall, Northallerton.

### County Hall in 1908

Building began in 1903 and the William and Mary baroque County Hall officially opened in 1906. The original building shown here was designed by Walter Brierley of York and cost £33,264 16s 11d plus the £5,350 cost of the land which had been a football pitch on the racecourse. Extensions were added in 1916, 1930 and 1940. The establishment of Northallerton as the administrative centre of the North Riding was anticipated by the Registry Office in Zetland Street in 1736, the Prison in 1783, the House of Correction in 1783 and the Governor's House and the Court House in 1785. County Hall served as a thirty-two bed Red Cross Hospital in the Second World War.

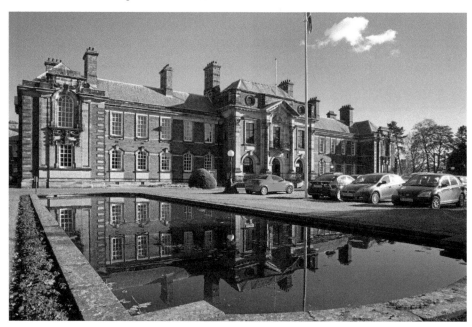

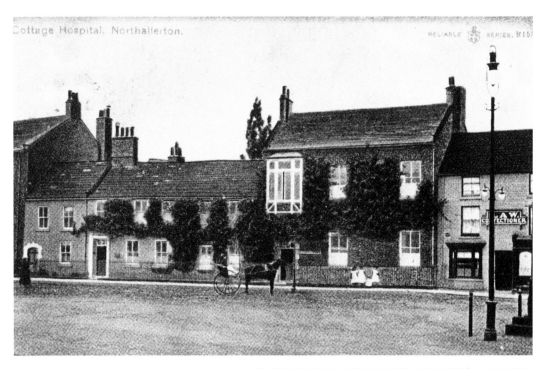

## Rutson Hospital

Originally the six-bed 1877 Cottage Hospital built on the site of the old Carmelite Friary, the name changed in 1905 to Rutson Hospital to honour its benefactor, Henry Rutson of Newby Wiske, who had been an eye patient there. It was originally called Vine House on account of the fact that it sported the largest vine in England – 200 years old and covering 137 sq. yards; it was a Black Hambro and was nicknamed The Bleeding Vine on account of the discharge from it. The North Riding Quarter Sessions were held here between 1720 and 1770 and it was the town's post office from 1850-1876. Wounded from the Second World War were nursed there when it was an emergency station. The vine is largely gone and the hospital is now closed with services provided at the Friarage Hospital.

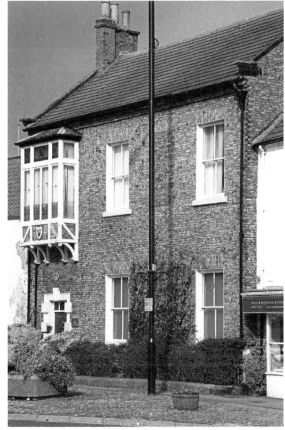

19

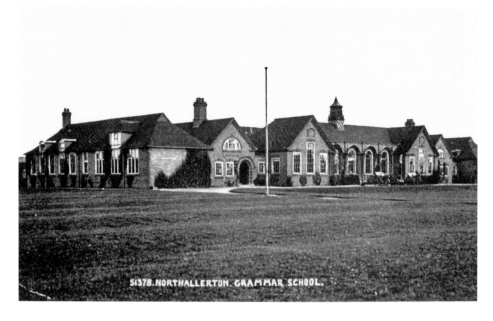

51378.NORTHALLERTON. GRAMMAR SCHOOL.

## The Grammar School and the Tin Bath

The grammar school moved here to Grammar School Lane in 1909. There is an impressive roll call of old boys: one was a centenarian, two were chaplains to Charles II, Dr William Palliser, Archbishop of Cashel in Ireland, another physician to Mary II and Queen Anne, and another, John Hickes, was hanged for his part the Monmouth Rebellion and Dr John Radcliffe who founded the Radcliffe Library in the Radcliffe Camera in Oxford and after whom two local hospitals are named. Disruptive pupils were confined in an (empty) tin bath kept in the corner of the classroom by a Dr Nugent. During the Second World War the school was requisitioned by the Green Howards, hence the flagpole and field guns to the right. Pupils meanwhile had lessons in County Hall.

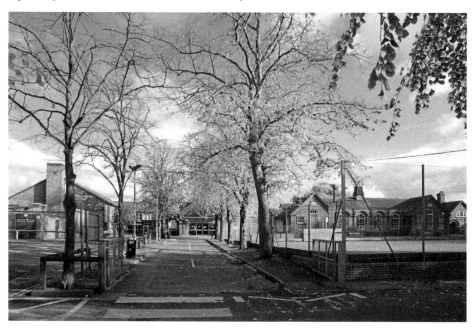

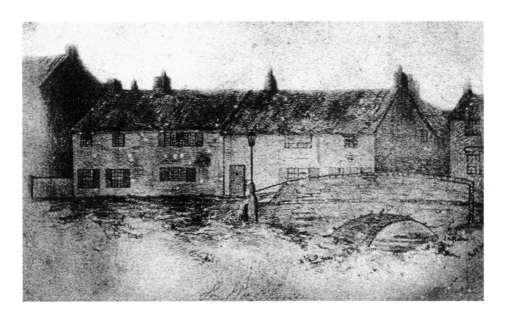

### Northallerton Union Workhouse

A mid nineteenth-century sketch. The original workhouse had been in the Guild Hall built by Cardinal Kemp, Archbishop of York, in 1444 and the venue for the North Riding Quarter Sessions between 1558 and 1730. The workhouse took over the building when the Guild Hall moved over the road to Vine House. Seven local men were hanged here for treason in 1570. The workhouse moved to a new building built in 1857 on Friarage Fields – the site of the Carmelite Friarage for the Northallerton Poor Law Union and is now part of the Friarage Hospital; the old building was demolished in 1863; Northallerton Savings Bank was built on the site which is now the offices of Jefferson & Willan, solicitors. The bridge took pedestrians and horses over Sun Beck which originally flowed down the surface of the High Street and Bullamoor Road.

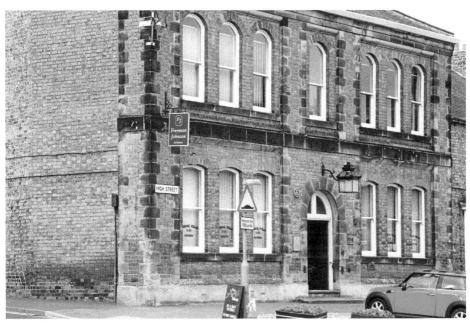

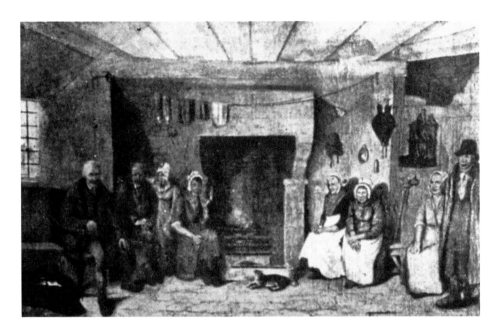

### Fally Flower and Rachel Bussey

A captivating 1832 painting by someone called Wheldon which could be seen in the Poor Law Board of Guardians room in the Sun Beck House workhouse until the mid 1940s. We can identify some of the characters: Fally Flower, the Irish lady smoking the pipe; Rachel Bussey seated second right – she once lived in Tickle Toby Yard and Robin Simpson, former fishmonger, on the far left. The workhouse was referred to locally as *The Bastille*; it took workmen three days to clear the garbage from the back yard when it was closed down in 1857 and subsequently demolished. The modern photograph is of the vagrants' bathroom (looking towards the Receiving Room) in the workhouse museum reconstruction in nearby Ripon. The sign is characteristically stern.

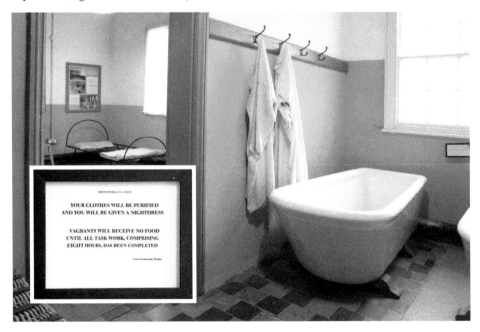

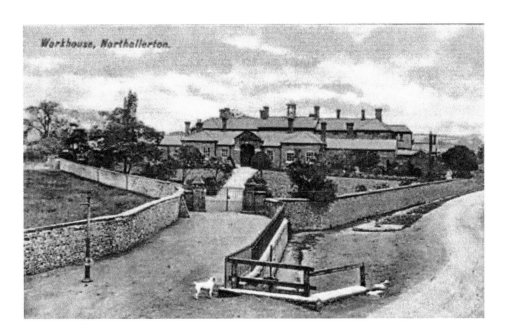

## The *Bastile!*

Feelings ran high locally about the workhouse. Passers by over the bridge on the way to church were disturbed by the inmates in their blue and white uniforms peering out of the windows at them. Tommy Nevison paraded a banner at every parliamentary election depicting the workhouse with the inscription *"Bastile"* (sic). Changes to the Poor Laws led in 1837 to the Northallerton Poor Law Union covering 40 parishes and a population of 12,460. The new 1857 building accommodated 125 inmates some of whom traded casual maintenance work in return for meals. The modern photograph shows part of the Friarage Hospital which subsumed the workhouse buildings.

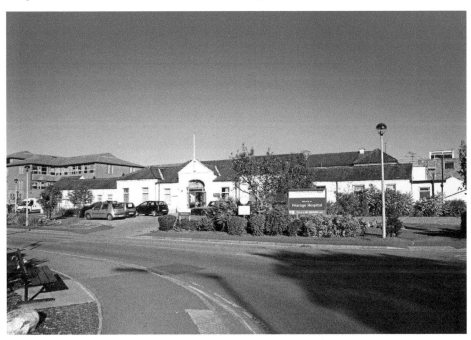

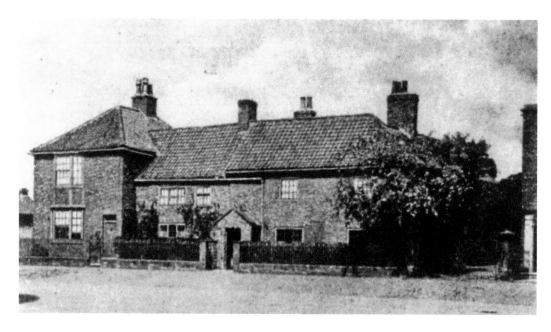

Porch House and Charles I

An early twentieth century picture of the oldest house in Northallerton; renovations in 1844 revealed the carved initials on an oak beam of Richard Metcalfe and Margaret his wife, 1584. The porch bears the date 1674 and the initials of William Metcalfe and of Anna his wife. The Metcalfe's were local dignitaries – their seat was at Nappa Hall – and staunch Royalists in the Civil War. They accommodated Charles I in the house on two occasions: first in August 1640 and later in 1647 when he was a prisoner of the Parliamentary Comissioners.

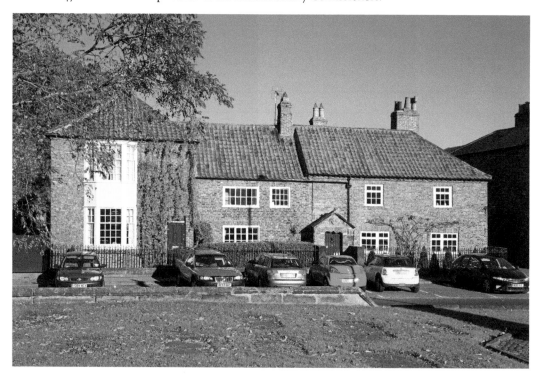

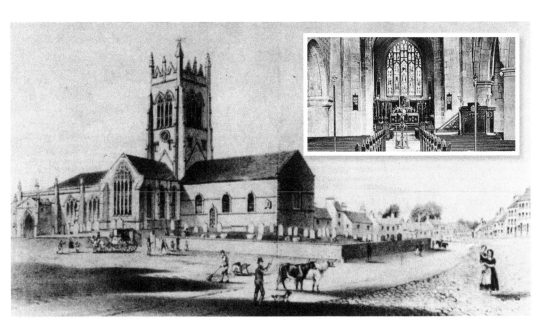

## All Saints Church

The first church here was a wooden building erected by St Paulinus in the seventh century; this was followed by a ninth-century Saxon stone church. The present Norman Perpendicular style church dates from around 1120 although the tower is fifteenth century. The interior was renovated extensively in the 1884; the font, however, dates from 1662. Work by Robert Thompson was introduced more recently bearing his famous mouse signature on the Baptistry panelling and Lady Chapel screen. John Fisher, later Bishop of Rochester, was vicar of All Saints at the end of the fifteenth century. He was executed for his opposition to Henry VIII and canonised as a saint by the Roman Catholic church in 1935.

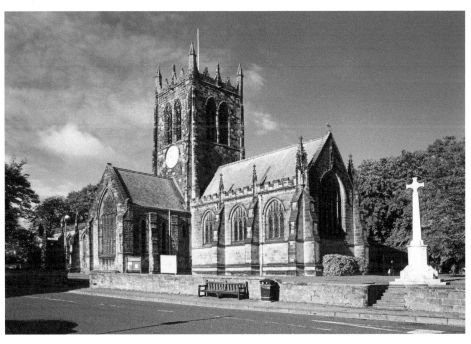

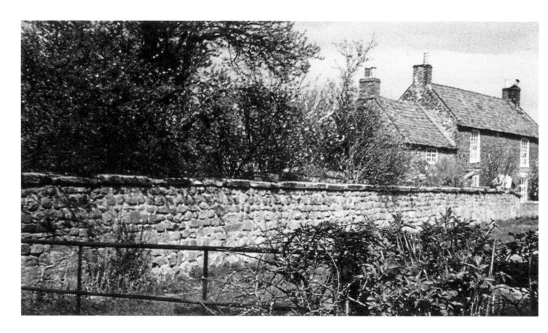

## Hospital Farm

On the left on the Thirsk Road going out of Northallerton this is the site of St James' Hospital which was founded around 1155 and run by a priest and twenty-one church-trained staff. It looked after thirteen patients and each night, after the tolling of the night bell, up to thirty "out-patients" who needed food. The basic structure of the old hospital is largely preserved in the farm today. At the Dissolution Henry VIII in 1539 transferred the land and property of the hospital to an endownment for Christ Church College Oxford.

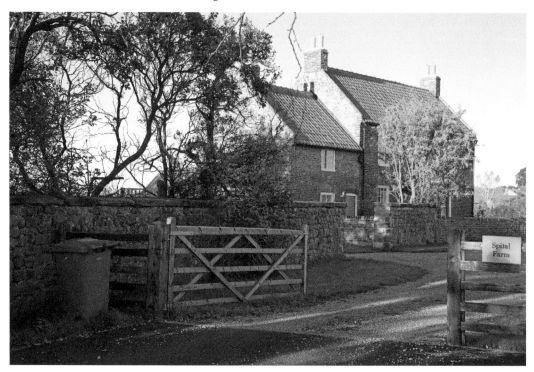

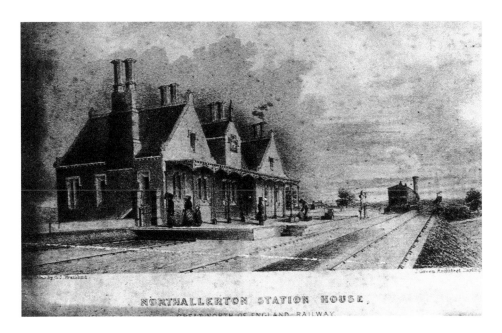

NORTHALLERTON STATION HOUSE,
GREAT NORTH OF ENGLAND RAILWAY.

Northallerton Station House in 1845

An 1840 print of the "Elizabethan Gothic" station soon after it was built. The line here was opened in 1841 as part of Great North of England Railway Company London to Darlington line, completed to Gateshead in 1844, a 303-mile journey which took 9 ½ hours. In addition, the station served a branch line to Hawes from 1877 which serviced the quarrying in Wensleydale (see page 28); and the Leeds-Stockton branch line from 1854 with a station and goods yard at North End. Northallerton could boast the country's most modern signal box to the right here when it opened in 1939, now demolished. The canopy to the left was made of glass, demolished in 1985. Over 500 railway workers were employed at one point, many living in Romanby.

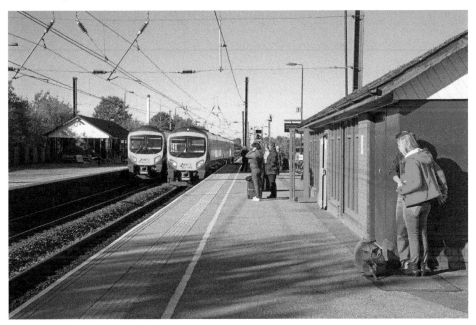

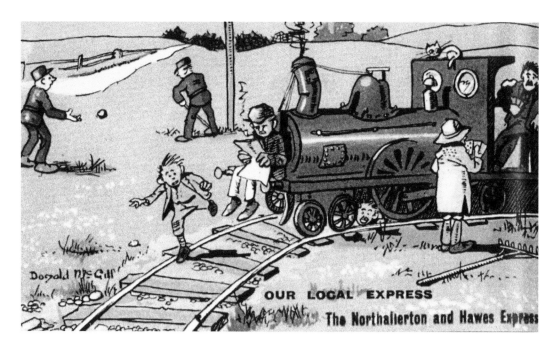

### The Hawes Express

A comic postcard from the 1920s celebrating the line and its dedicated engine, *Old Faithful*, or more popularly, *The Bedale Pusher*. The 40 mile Wensleydale branch line to Bedale, Leyburn and Hawes had been opened in stages between 1848 and 1878 joining the main east coast main line immediately north of the station. Passenger trains were withdrawn from 24 August 1954, although it remains open for occasional trains operated by the Wensleydale Railway Association. By 1964, only 22 miles of track were maintained between Northallerton and Redmire to transport quarried limestone to Teesside until 1992. The new picture shows the Wensleydale Railway at Bedale.

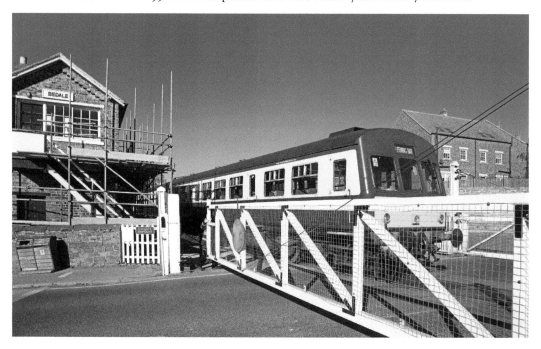

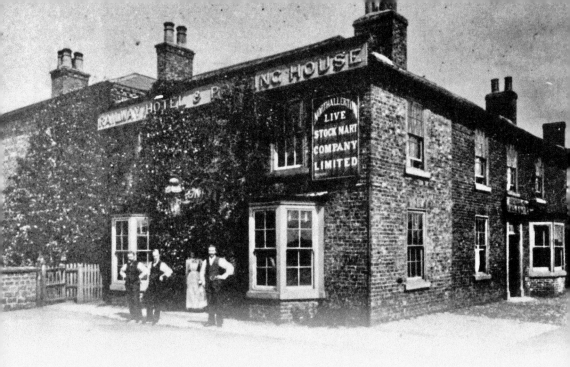

CHAPTER 3

# Pubs and Cafés

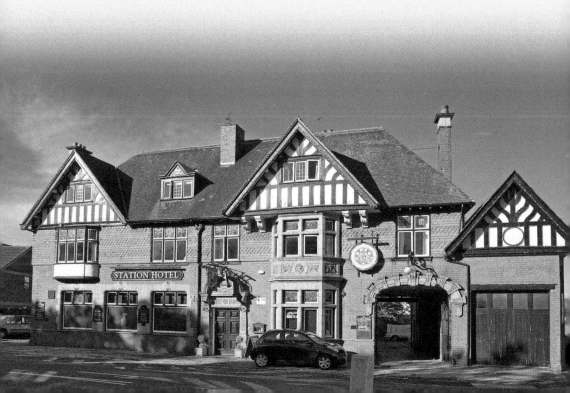

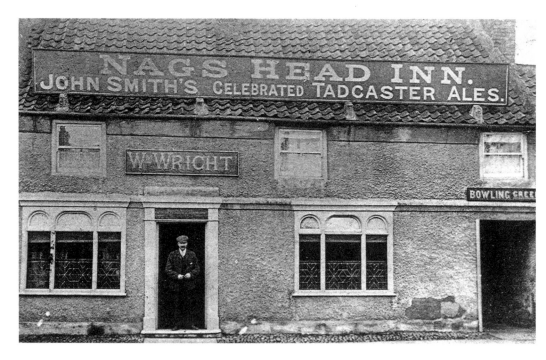

**The Nag's Head 1898**

A seventeenth-century pub which still survives today as a John Smith hostelry at 144 High Street. The licensee, William Wright, can be seen here in the doorway. Mr Wright, in common with many licensees of the time, had a day job – in this case carpentry. His work includes the front door of the North Riding County Hall. Note the bowling green sign. Northallerton had a reputation as a drinker's town with twenty-seven pubs in the High Street at one time. Giles Mornington's 1697 eulogy to Yorkshire ale puts it well: *"Northallerton, in Yorkshire, does excel /All England, nay all Europe, for strong ale."*

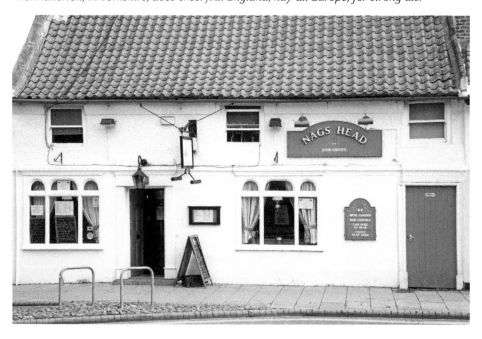

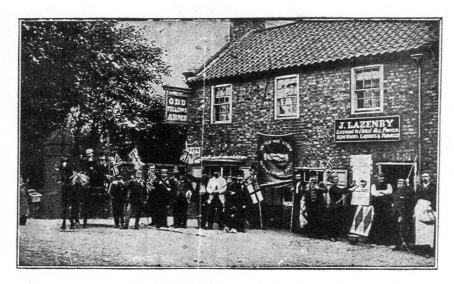

## "GOOD OLD NORTHALLERTON."

### The Odd Fellows Arms

An 1889 photograph showing a group of Oddfellows order members gathering outside J. Lazenby's Odd Fellows Arms at 249 High Street prior to a spot of electioneering on behalf of the Conservative candidate, a Mr Elliott, during the Boer War – another John Smith pub still serving today. The Oddfellows is one of the largest and oldest friendly societies in the UK. It grew out of the medieval trade guilds, beginning in the City of London in the late seventeenth and early eighteenth centuries. By 1850 the Independent Order of Oddfellows Manchester Unity Friendly Society was the largest and richest friendly society in Britain. Only by joining mutual friendly societies like the Oddfellows could people protect themselves and their families against illness, injury or death. In 1911, when the Asquith Liberal government was preparing the National Insurance Act, they used Oddfellows' actuarial tables to calculate the levels of contributions and payments. Today the Oddfellows is a social and care organisation with 120,000 members worldwide.

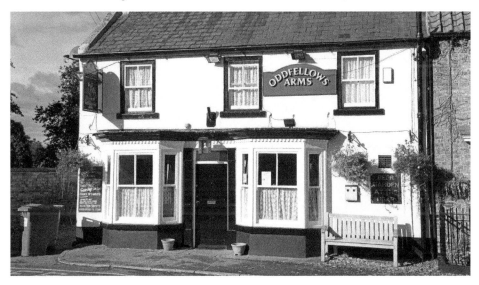

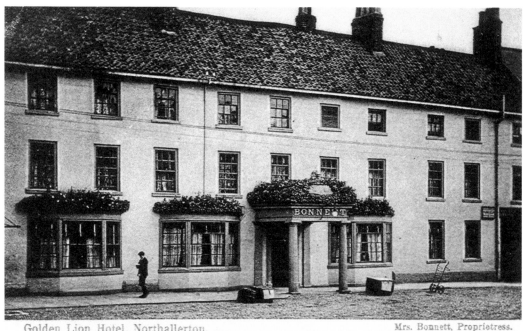

Golden Lion Hotel. Northallerton.                    Mrs. Bonnett, Proprietress.

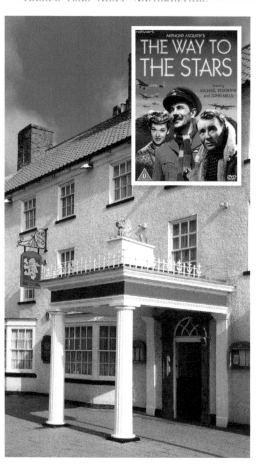

## Golden Lion Hotel

Run by Mrs Bonnett in 1900 this elegant hotel was built in 1730 and became an important stop for stagecoaches on the York to Edinburgh road. Famous coaches such as the "Royal Mail", "The High Flyer" and the "Princess Charlotte" called here. There was stabling for seventy-five horses which were washed, appropriately enough, at Water Pond, later the site of the prison, and grazed in Golden Lane field off Grammar School Lane. Guests included the future Czar of Russia, Grand Duke Nicholas and his entourage in 1816 which included Grand Duke Constantine and William Congreve; Queen Victoria's third son, the Duke of Connaught (1876), and Andrew Carnegie, the Scottish-American philanthropist (1888). The railways of course killed off the stagecoach business and the population of Northallerton fell from 3088 in 1841 to 2876 by 1871 as a direct result. Ironically the hotel ran a horse and coach shuttle service to the railway station. During the Second World War it was frequented by aircrew from Leeming and other nearby air force stations; scenes were shot here for the epic cult war film *"The Way to the Stars"* produced in 1944 and starring Michael Redgrave, John Mills, and Rosamund John.

## Betty's Café Tea Rooms

The older picture shows the original Betty's which opened in 1971 after the move from Leeds. Now in a Grade II listed Georgian building since 2004 Betty's features a courtyard, the 'Palm Room', with a domed glass roof, massive window mirrors and a 3 metre high Chusan Palm. There are, of course, other Betty's tea rooms nearby: Harrogate, Ilkley, Harlow Carr and two in York, one of which was inspired by the liner Queen Mary when in 1936 the founder, Frederick Belmont, travelled on the maiden voyage. Who was Betty? No one knows for sure but it could either have been Betty Lupton, Queen of the Harrogate Wells from 1778-1838 and chief "nymph", or the actress Betty Fairfax who starred in the West End musical *Betty* around 1915 or, just as plausibly, the name of the maid who brought in the tea when the name for the new café was being discussed...

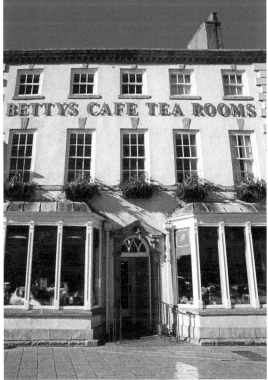

# The RUSSELL CAFÉ,

## Market Place,

## NORTHALLERTON

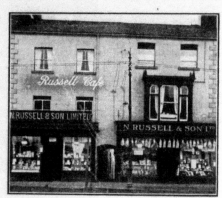

*Parties visiting Northallerton will find The Russell Café the best place for a substantial meal at a reasonable price*

*Dinners, Weddings, Whist Drives, Socials, Receptions, and Ball Suppers catered for.*

HOT & COLD LUNCHEONS DAILY.

Afternoon Teas. High Teas. Refreshments. Smoke Room.

PROMINENT, COMFORTABLE and CONVENIENT.

Tel. 16.    AMPLE ACCOMODATION.

14

The Russell Café
A popular haunt for generations of Northallerton residents and visitors which closed down in the 1960s. This 1922 photograph clearly shows the extensive range of facilities on offer – from weddings and balls to high teas to bedrooms. The café was run by Nathaniel Russell at the time. Apart from teas and coffee, a 1905 advertisement tells us that they also sold *"finest Wensleydale cheese, crystallized fruit in great variety, Carlsbad plums, Muscatels, biscuits in fancy tins &c..."*

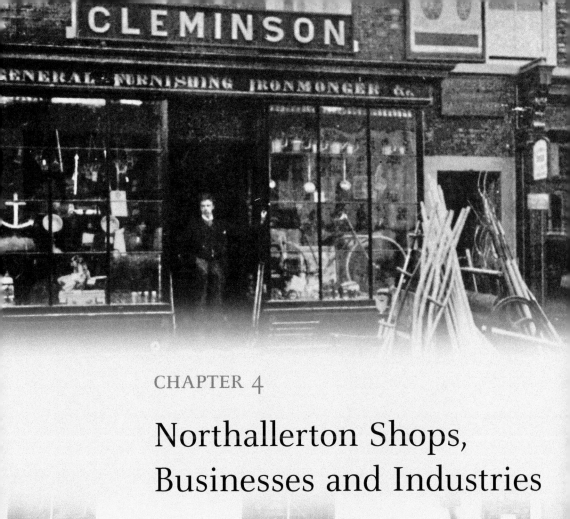

CHAPTER 4

# Northallerton Shops, Businesses and Industries

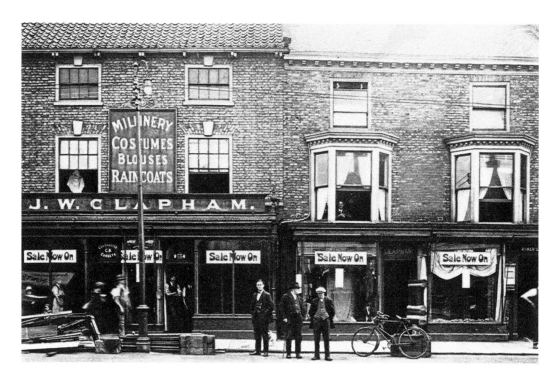

### J. W. Clapham 1910

Drapers, milliners and hosiers in the High Street possibly undergoing some shopfitting if the wood at the front of the shop is anything to go by. Mr Clapham went to the USA to gain some retail experience and returned to build up what became a thriving business from 1885. The shop ran fashion shows in the 1950s. By the 1960s a café had been added with another new façade and it eventually merged with the Middlesborough company Uptons in 1965. The site is today occupied by a branch of Boyes.

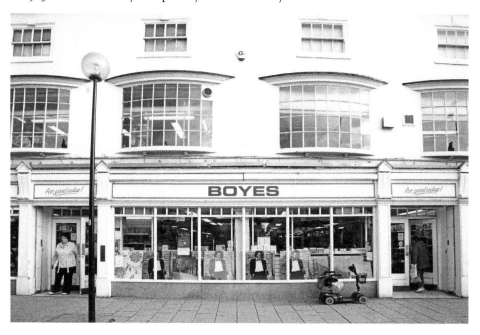

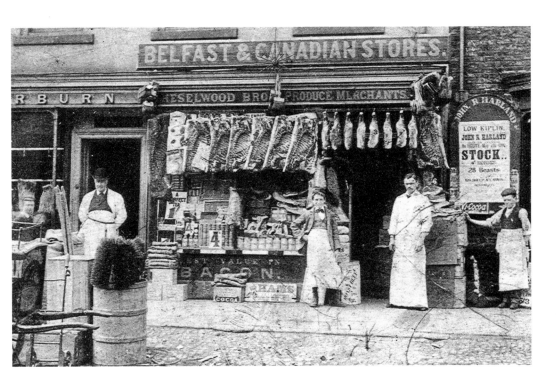

**Belfast & Canadian Stores**

Now Barker's Harvest Kitchen cafeteria this 1897 picture shows an impressive range of meat and groceries on offer at the High Street shop run by the Heselwood brothers. George Hudson took over the business in 1891; it was then bought by the Truemans who run it to this day, albeit on the other side of the High Street. Fairburns the butchers are on the left (that's Charles Fairburn in his doorway). John Harland's poster for a sale of twenty-eight beasts (horses) is visible on the right.

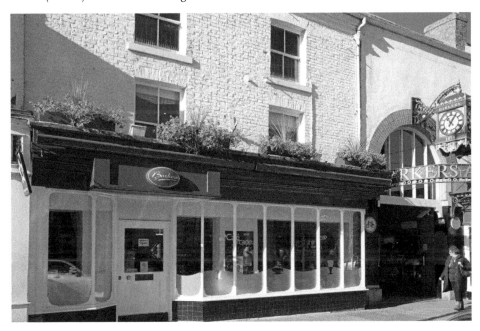

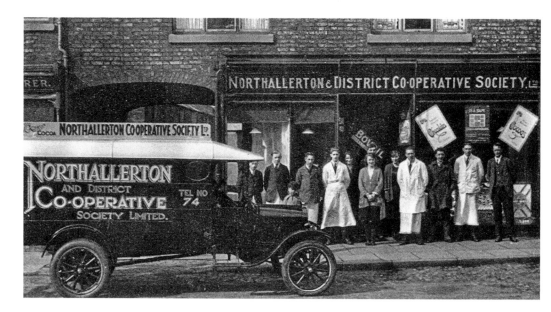

**Northallerton & District Co-operative Society Ltd**
A 1927 photograph of staff and delivery van outside their High Street branch. The Co-op grew out of The Rochdale Society of Equitable Pioneers – a group of twenty-eight weavers and other Rochdale workers. At the time, increasing mechanisation was leading to increasing unemployment and poverty so they scraped together £1 each together to raise £28 capital. On 21 December 1844, they opened their shop with a meagre stock of butter, sugar, flour, oatmeal and candles. After three months, they branched out into tea and tobacco and soon won a reputation for high quality provisions. By 1854, the co-operative movement had nearly 1000 shops. The modern photograph shows the Co-op Travel shop in the High Street.

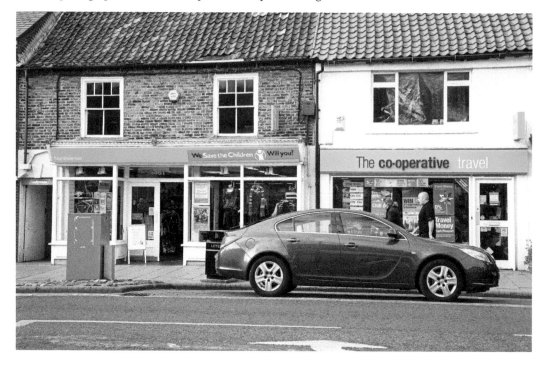

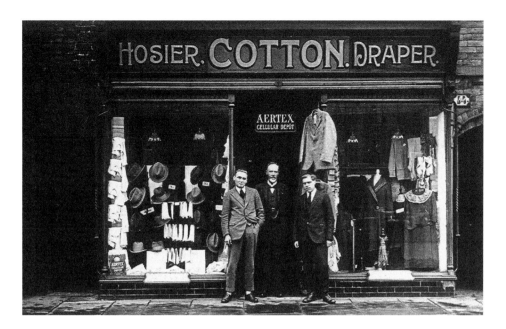

### John Cotton

John Cotton, pictured here on the left sometime in the 1920s with colleagues, ran one of three hosiery and drapers shops in the town at the time: the others were Barkers and Claphams. Cottons continued trading until the early 1940s. As you can see, Cotton was an agent for Aertex. In 1888, Lancashire mill owner Lewis Haslam trialled his theory of aeration whereby air is trapped in the warp and weft of the fabric. The result is a cellular cotton fabric which makes a barrier between the warmth of the skin and the cool of the atmosphere. The British Army first wore 'Aertex' in the Second World War. *"Aertex captured the dowdy appearance of the late 1900s Britain and transformed it into a stylish example of forward thinking fashion".* The modern shot is of the High Street from nearby Black Bull yard.

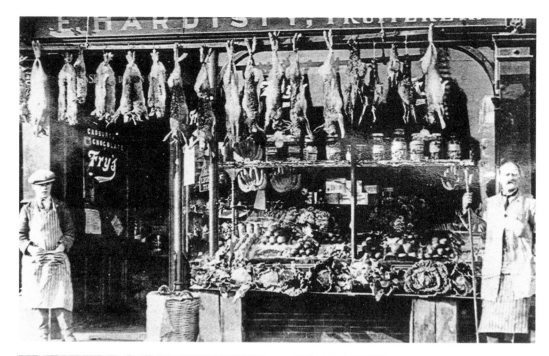

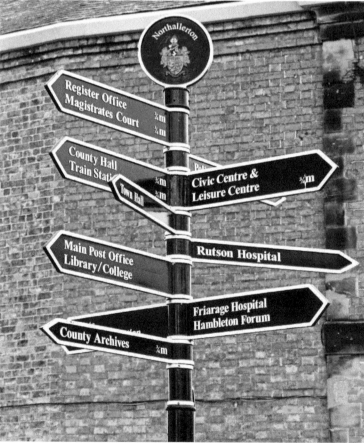

## Hardisty's

What a splendid display – everything from hung game to chocolates from Fry and Cadbury (who merged in 1919)! Hardisty's specialised in fresh fruit but that didn't stop them from keeping a veritable treasure trove of products. Young George Hardisty is on the left; Frank, the owner, to the right. Today's signpost – apart from neatly advertising many of Northallerton's sites and attractions – is in the vicinity of Hardisty's site – near to the Applegarth car park entrance.

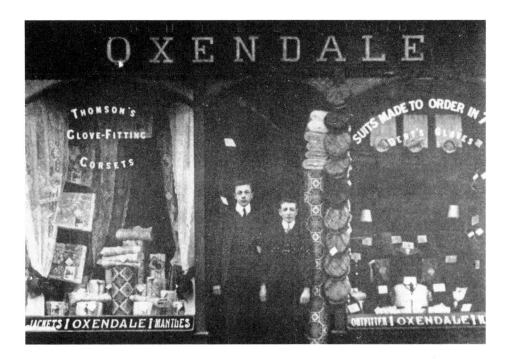

### Oxendale and the Glove-fitting Corsets

Thomson's glove-fitting corsets must have been a relief. This late nineteenth century picture shows two of the draper's shop assistants. Apart from gloves, mantles and corsets Oxendale & Co were noted wholesale furriers. A 1905 mail order catalogue promotes *"lovely white Foxeline stoles – very smart and becoming. Broad shoulder cape, lined best white satin, 9 inches in length"* at 24s/6d and *"new large bag-shaped muffs"* at 8s/11d. For many years Oxendale was in partnership with Barker's – a business which survives today and is itself very much at the *"smart and becoming"* end of the market.

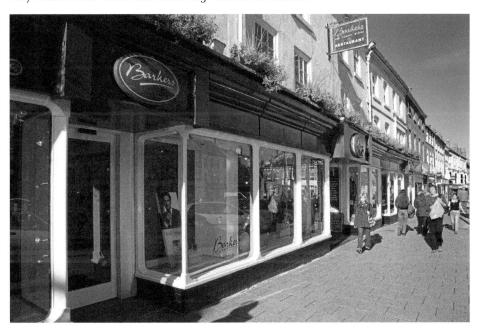

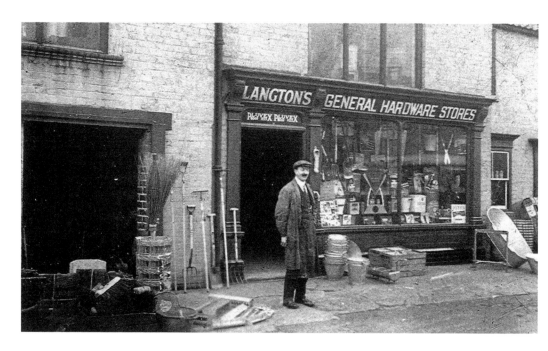

Langton's: *"Joiners' and Builders' Tools of Every Description"*

General hardware stores pictured in the 1920s. The gentleman outside the shop was Albert Roper who worked for Langton's as ironmonger. Some of his fine work can be seen here, including a tin bath. Pluvex roof felt is advertised above the door; the company still makes bituminous damp proof courses. A 1912 advertisement reads as follows: *"Langton & Son...beg to draw your special attention to their large and varied stock...including kitchen ranges, tiled register stoves, enamelled slate mantelpieces, tiled hearths, combustion stoves."*

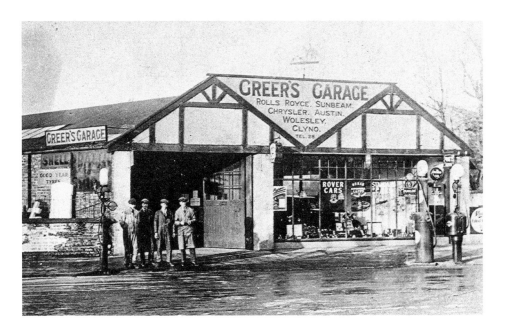

Greer's Garage

On the corner of the High Street and South Parade (now demolished) this 1929 photograph shows Mr Pattison, the foreman, with three mechanics next to the hand cranked petrol pumps. As the signage shows, Greer's were Rolls Royce and ... Clyno dealers. In its heyday Clyno was the UK's third largest car manufacturer after Austin and Morris. The Clyno's unique selling point was that it offered a price as low as any similar car in the world, and much higher value for money. During the First World War Clyno signed an agreement with the Russian War Commission for the supply of solo and combination machines for the Imperial Russian Army comprising mobile machine gun units, ammunition carriers and solo machines. During 1918 and 1919 Clyno also built a number of ABC Dragonfly aero engines.

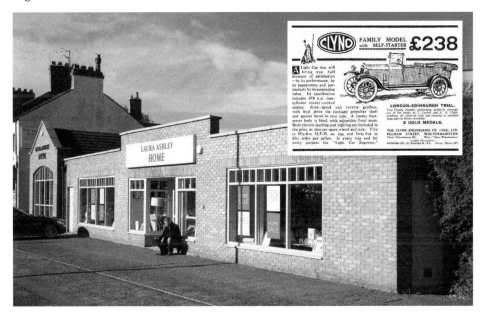

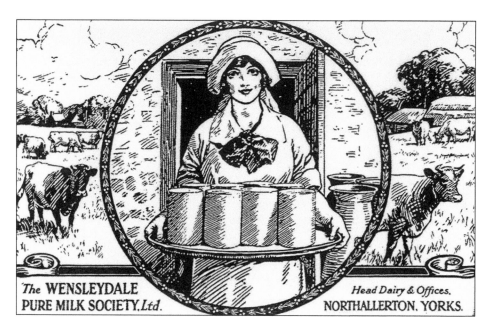

The WENSLEYDALE PURE MILK SOCIETY.*Ltd*.

Head Dairy & Offices.
NORTHALLERTON. YORKS.

### The Wensleydale Pure Milk Society Ltd

An early advert for a company which survived, in one guise or another, for 105 years after its formation in 1905 as a local cooperative of dairy farmers. It became Dried Milk Products and in 1932 was taken over by Cow and Gate, then Unigate when Cow and Gate merged with United Dairies. By 1911 759,763 gallons were being forwarded annually from Wensleydale to the WPMS depot at Northallerton. In 1965 between 20 and 30,000 gallons of milk were received daily, initially via the nearby North Eastern Railway. Indeed, it was because of the arrival of the railways that WPMS was set up in the first place – a solution had been found for the bulk transportation of milk from farms and dairies to purification plant and then on to market. The dairymen used the 'Cream Special': a four-wheel trolley to transport milk and dairy products on the railway. Today the site is occupied by the Arla Foods creamery which closed in June 2010.

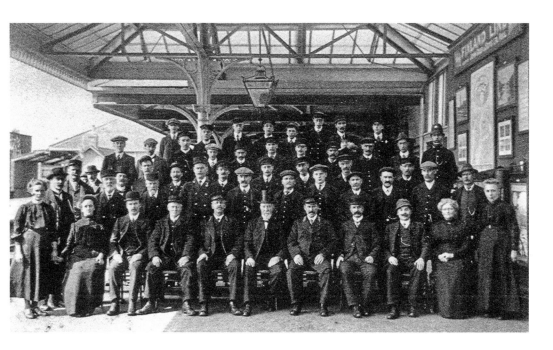

Railway Staff 1913

A splendid 50 men and women turn out to mark the retirement of Station Master Thomas Beecroft – he's the one in the middle of the front row wearing the top hat. Nearly 100 trains called there each day. The ladies on the left were Mrs Archer and her daughter who looked after the refreshment room; those on the right ran the ladies' waiting rooms. The ticket collectors are wearing the box hats; the man to the left of the station policeman had the bookstall. Today three staff run the station.

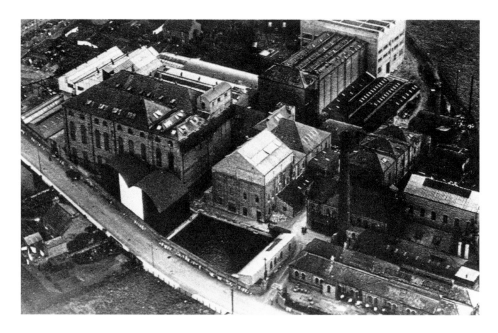

## Northallerton Linoleum Company

A 1922 picture of the town's chief employer at the time – nearly 200 people worked there between Malpas and Romanby Road. It was owned by Miles, Sykes and Son Ltd from 1912 and had been founded in the 1860s by the then MP for Northallerton, Sir George Elliott. Production originally comprised tarpaulin and brattice cloth with lino, harnesses, horse cloths and car covers coming on stream after 1912. In 1938 Miles, Sykes & Son Ltd went bankrupt and the factory was disposed of in 1944. The site was subsequently used from 1947 by Helix Springs (manufacturers of mattress springs) until the '70s, and then by Allerton Industries which subsequently moved to Darlington Road in 1974. The new photograph is looking on to the site from Romanby Road, now Weavers Green.

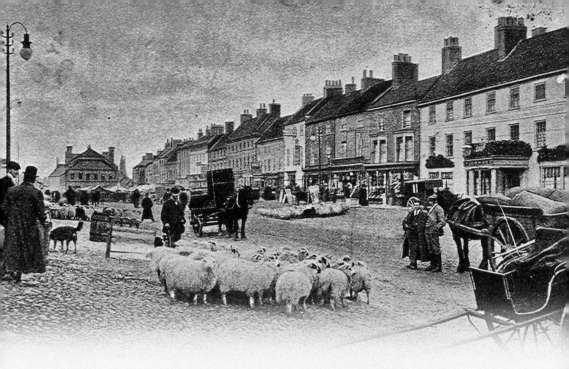

# CHAPTER 5

# Northallerton Events and People

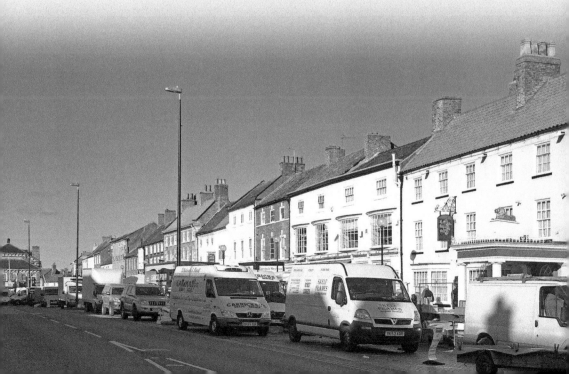

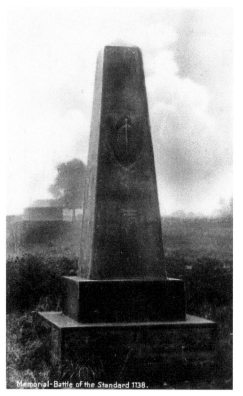

Memorial-Battle of the Standard 1138.

### Battle of The Standard Memorial

The memorial marks the site of the 22 August 1138 battle where 12,000 marauding Scots led by Prince Henry and his father, King David I, moved south devastating the land as they went in support of the Empress Matilda's claim to the English throne. King Stephen was pre-occupied in the south of England and the mainly "wild Galwegian infantry" were routed on Standard Hill, three miles to the north of Northallerton, by Archbishop Thurstan of York. Many of the Scots killed were buried along what was to become a bridle path graphically called Scot Pits Lane. The monument was set up in 1913 and the £26.18s it cost was paid for by public subscription.

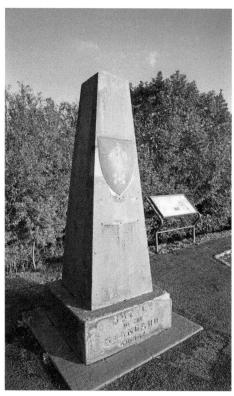

### The Standard

The huge "standard" in question is the religious standard – a ship's mast with a silver pyx containing the Holy Sacrament on top – specially created in what had became something of a holy war. The banners are those of St Peter of York, St John of Beverley and St Wilfred of Ripon. The whole thing was transported on a four-wheeled cart. The standard shown here is a 1652 replica. The modern shot is the splendid sign on The Standard pub in North End.

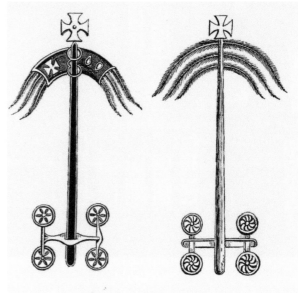

Figures of the Standard.

From Aelred's "Historia de bello Standardi."
(Twysden's Decem Scriptores.)

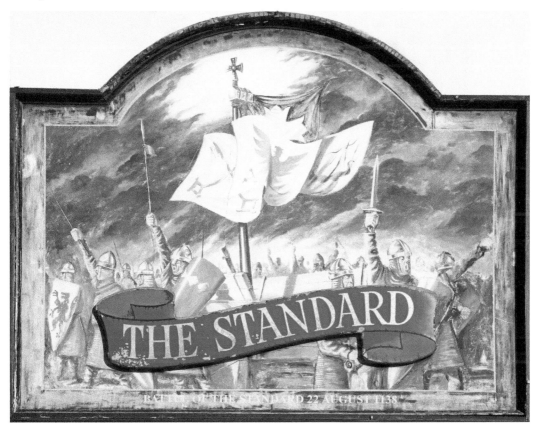

BATTLE OF THE STANDARD 22 AUGUST 1138

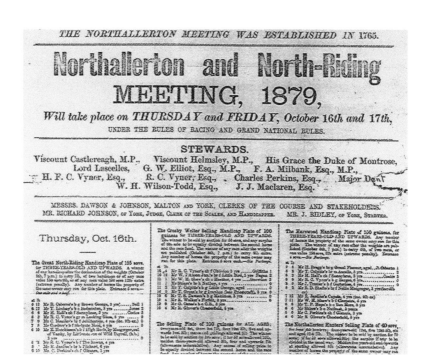

**Northallerton Races**

An 1879 poster advertising the penultimate meeting of Northallerton Races which had started in 1765 and ended in 1880. Northallerton had been one of the top meetings in the north of England with a Gold Cup (100 guineas) and a Silver (50 guineas). The arrival of the railways was partly to blame for the closure as the route of the line behind Broomfield Farm reduced the circuit considerably. Today you have to go to Thirsk to see horse racing.

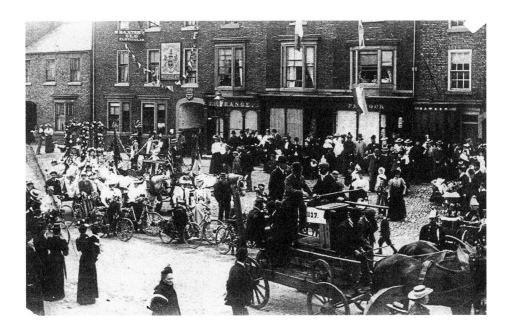

## Diamond Jubilee

The 1897 Queen Victoria Diamond Jubilee with crowds processing down the High Street past The Harewood Arms, later The Tickle Toby, advertising Baxter's Old Particular Ale from Thornton-le-Moor brewery; note licensee Mr Macaulay's splendid inn sign in the centre. The *Darlington and Stockton Times* described the day thus: *"Altogether the day was the most memorable day of general enjoyment that has been known in Northallerton"*. The procession was led by the Volunteer Band and the Boys' Own Drum and Fife Band. There was tea for all at the Town Hall on sixty-one trestle tables with continuous sittings culminating with a sitting for the town's "vagrants". Seventeen cartloads of wood were burnt for the beacon fire and fireworks display on Bullamoor.

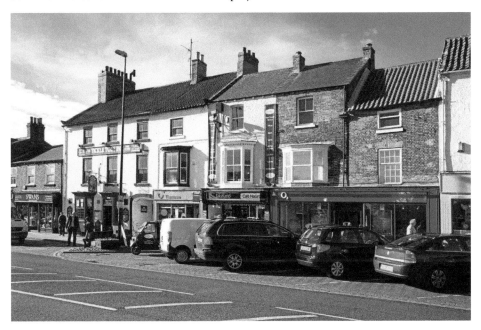

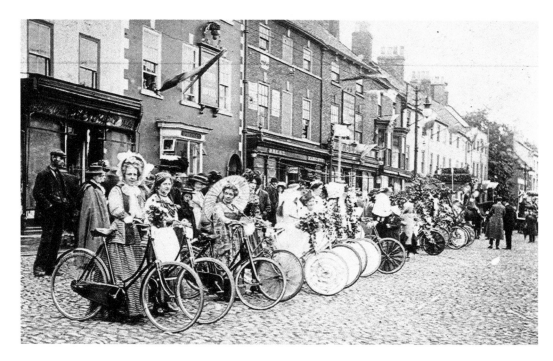

Carnival 1910

A typical scene from Northallerton's annual carnival which shows a wide array of fancy dress and decorated bicycles. A great opportunity to dress up and have fun, this bicycle parade sports geisha girls, gypsies and matrons while the judges deliberate on the right. The inset from the 1930 carnival shows that the fun had not abated. The North End Lodging House and Walter Thompson Builders are in the background.

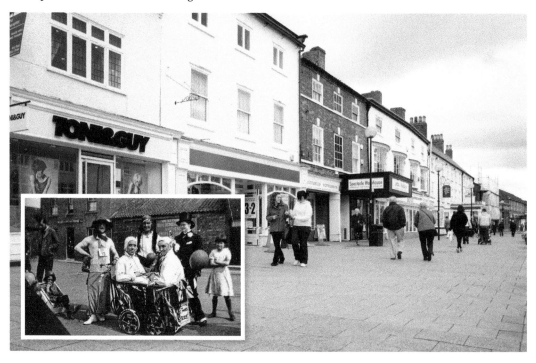

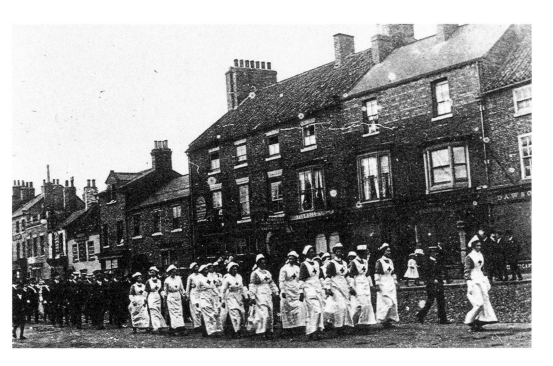

**Red Cross Parade**

A First World War parade passing The Harewood Arms. Part of County Hall was in 1914 converted into a 32-bed Red Cross hospital to care for wounded soldiers – 10 of the beds were reserved for Green Howards (4th Bt. Yorkshire Regiment). Between 1914 and 1919 750 shot and shrapnel wounded soldiers were treated. The Commandant was local GP Dr Baigent famous in fly-fishing circles for his invention of "Baigent Brown" bait.

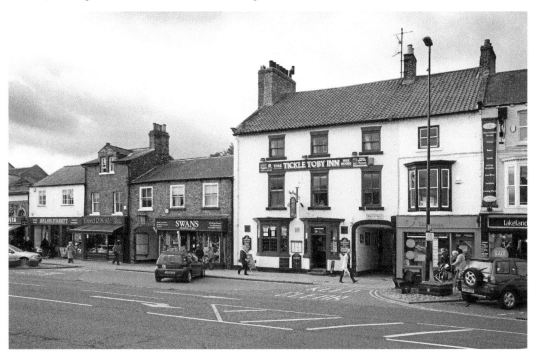

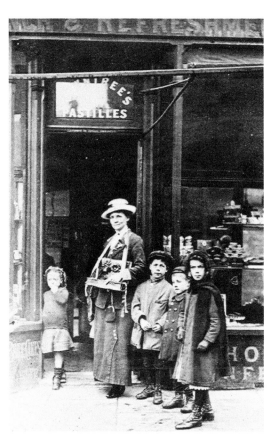

### Belgian Flag Day

Northallerton received a large number of Belgian children as evacuees during the First World War. The association with Belgium probably originates from around 1820 when one of the Wilford family went to Belgium and set up a linen factory at Famise; this *entente cordiale* continued into the twentieth century with an ongoing relationship between the linen trades in the two towns and their surrounding areas. The photograph is taken outside Wright's confectioners in the High Street near the Town Hall. Nearby Lewis & Looper retains a traditional shop front in the modern photograph.

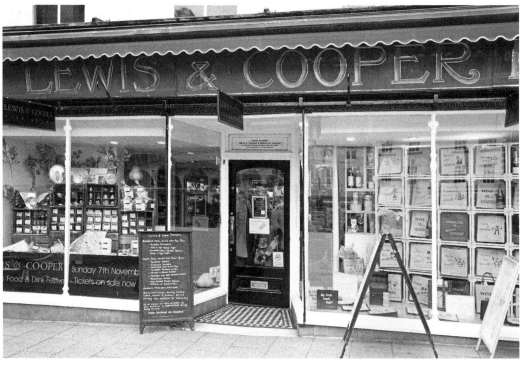

**PASSAGE TICKETS.**

**FOR CANADA AND UNITED STATES.**

W.R.S. is Agent for the following first-class Lines :— ·

**ALLAN, AMERICAN, WHITE STAR, & DOMINION**

Bookings through to any Railway Station in Canada or U.S.A.

**SOUTH AFRICA.**

Union Castle Mail Steamship Company, Limited, and Orient Line Mail Steamers.

**AUSTRALIA.**          **NEW ZEALAND**

*Reduced and Assisted Passages to Western Australia. Free Land. Emigrants to Western Australia, Farmers, &c., £2.*

For Dates of Sailings, &c., apply to Agent :—

**W. R. SMITHSON, Bookseller, Northallerton,**

Who has had 45 years experience.

---

"You need us when you ship goods abroad."

**MESSRS. PITT & SCOTT,**

(FOR WHOM

**W. R. SMITHSON, STATIONER,**

**NORTHALLERTON,**

IS AGENT),

**FORWARD GOODS TO ALL PARTS OF THE GLOBE**

TARIFF ON APPLICATION.

**Passage Tickets and a New Life**

An intriguing poster advertising at the top an opportunity to escape to a new life in one of five relatively new countries and then, in the lower half, export shippers Pitt & Scott. The agents for the passage tickets were local booksellers W. R. Smithson. Today's nearest equivalent are in Market Row although the trips they organise tend to be less permanent.

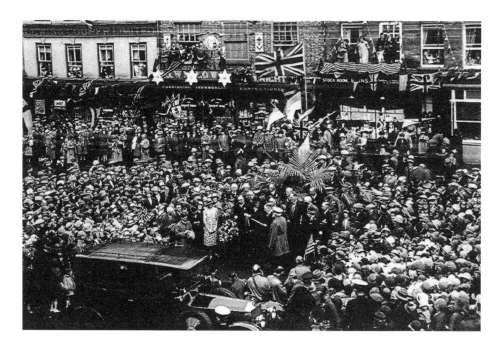

### Princess Mary comes to Northallerton

1926 saw Princess Mary's visit to Northallerton in her first engagement as Commandant of the Red Cross, to inspect the North Riding Red Cross, 800 of whose members were waiting on the cricket field (now the site of County Hall). Lewis & Cooper is in the background and Binns – where the Central Arcade is now. Lewis & Cooper were particularly famous – in home and export markets – for their hams and Wensleydale cheese. Contemporary adverts tell *us "every ham warranted perfection – satisfaction guaranteed or money refunded – 7d per lb – you cannot buy better whatever price you pay...many of our customers who have tried them have said I want another ham* "like the last *", it was perfection, that speaks for itself doesn't it?"* Other adverts maintain that their china and glass can be repaired, no matter how many bits it may be in. Smashing service.

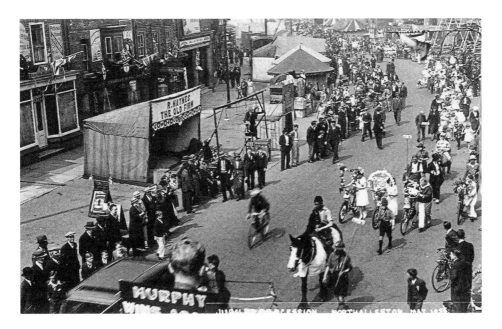

## George V's Jubilee

May 1935 – and another cause for celebration with a public holiday, a procession and lots of stalls and swings which can be seen in the top right corner. Note the health and safety careless spectators watching from outside their upper shop windows. The pillars of the Central Cinema can be seen at the top left – demolished in 1962 to make way for the entrance to the Applegarth car park. This was Northallerton's second cinema, the first being the 1913 Cinema de Luxe in Romanby Road. Central was built by Dan Oakley Ltd in 1920 where Melbourne Yard once stood. The 700-seater Lyric opened in 1939. The shops on the left include Coopers (painters), a picture framers, James Hogg with the Cherry Blossom shoe polish advert, and Hardisty's.

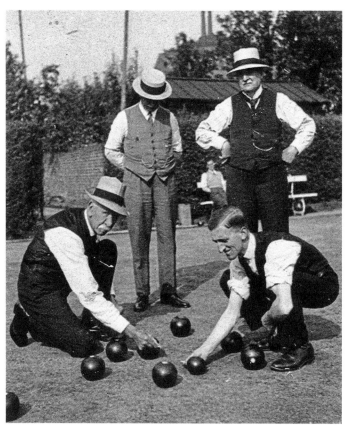

## Bowling and Barkers

A 1933 shot of members of the Northallerton Bowling Club. The Club opened in 1900 on the cycle track behind The Railway Inn; one of the founders was George Lewis, joint founder of Lewis & Coopers. The club moved to South End around 1910. The man standing on the left is William Barker who, born 1869, came to the town as an apprentice draper and lived with his boss, John Oxendale whose draper's store was founded in 1875. Barker eventually joined the board before going on to found Barker's of Northallerton. Their splendid sign and clock is shown in the modern photograph.

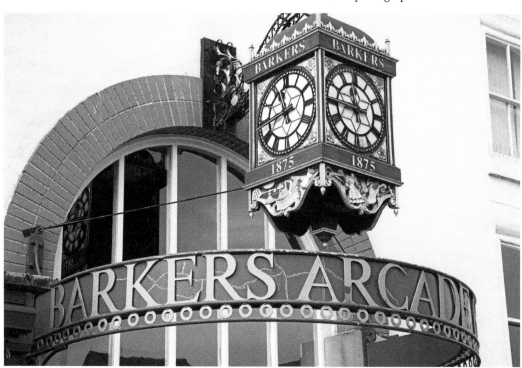

## Laying Electricity in Romanby Road

The Northallerton Electric Light and Power Company was founded in 1899 by Ernest Hutton. This gang is laying an underground cable along Romanby Road to the linoleum factory under the watchful eye of a Mr Fawcett seen here in the background. Romanby Road was of course part of the Great North Road joining Old Turnpike Road with the High Street. The Leopard, The New Inn and The Durham Ox were the three pubs here during the coaching days.

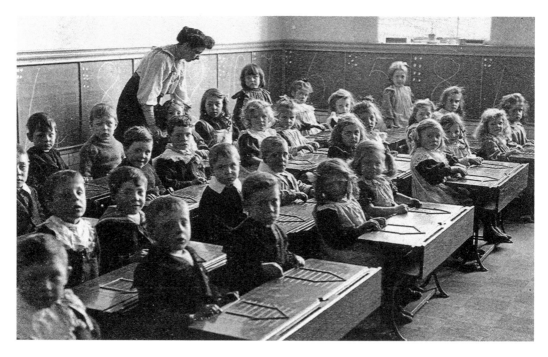

## Applegarth Infant School Class

Opened in 1908 at a cost of £4,329.8s the establishment of the school was a good example of local democracy. A dispute arose as to whether the school should be sited at East Road and annexed to the National Church of England School or alternatively at the non-denominational Springwell Lane. An election was held in which the Springfield faction won by 365 to 354 votes. Note the counting beads on the desks.

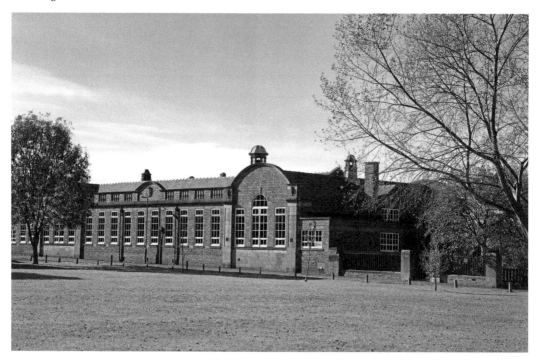

# CHAPTER 6

# Romanby

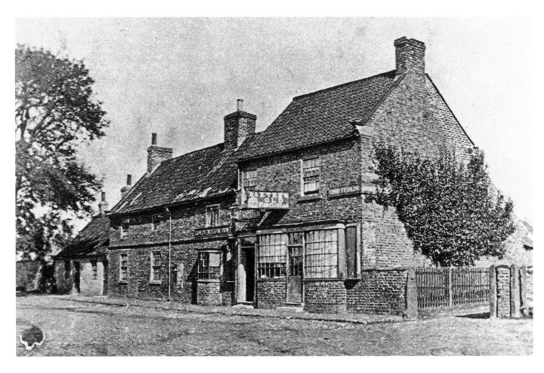

### The Golden Lion

An 1880s shot of The Golden Lion promoting Baxter's Old Particular Ale and good stabling. The bricked up doorway in the part of the building to the left suggests that this part was originally a row of cottages.

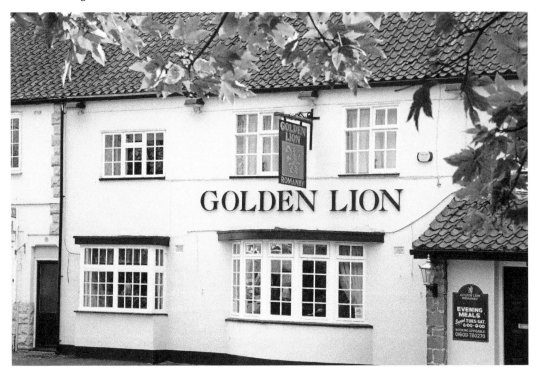

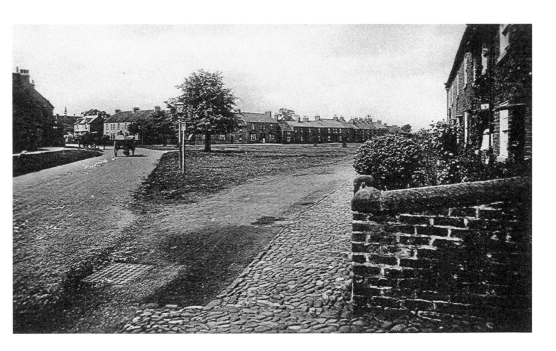

## Romanby Green

The cobbled path, gas light and horse and carriage passing The Golden Lion give the game away in a scene that has otherwise changed little in the 100 or so years that have elapsed since these photographs were taken. The population of Romanby has increased tenfold from 450 or so since the turn of the twentieth century and is now inseparable from Northallerton.

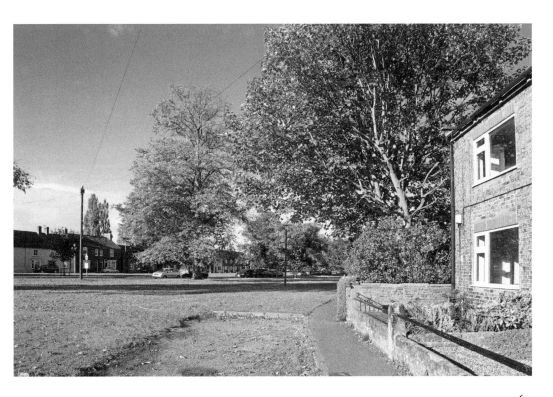

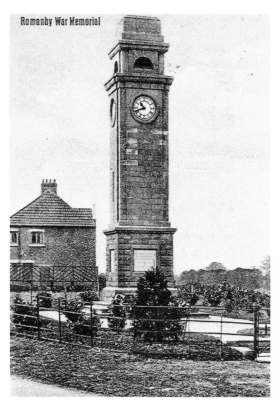
Romanby War Memorial

### War Memorial

The imposing War Memorial honours the fallen in the First World War and the Second World War. The first church here was granted in 1231 as a chapel of ease for All Saints in Northallerton. It was, however, destroyed in 1523 on the orders of Cardinal Wolsely after Leonard Hutchinson, Vicar of Northallerton, questioned Wolsely's authority. The new church pictured here was consecrated in May 1882, again as a chapel of ease.

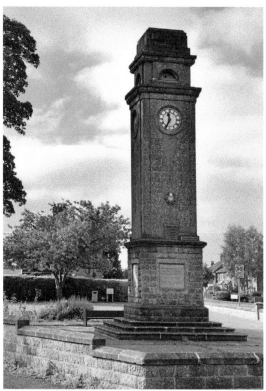

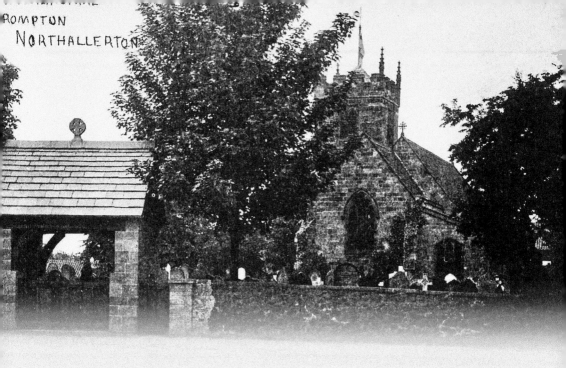

CHAPTER 7

# Brompton

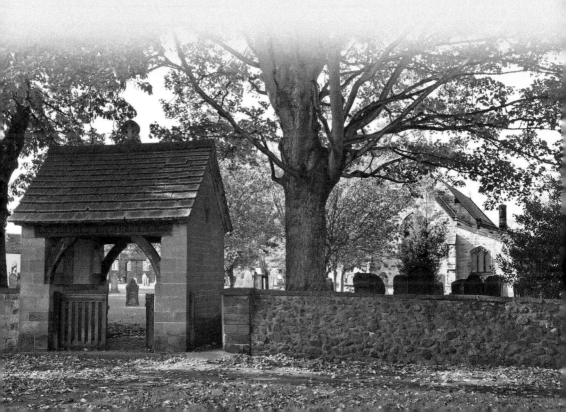

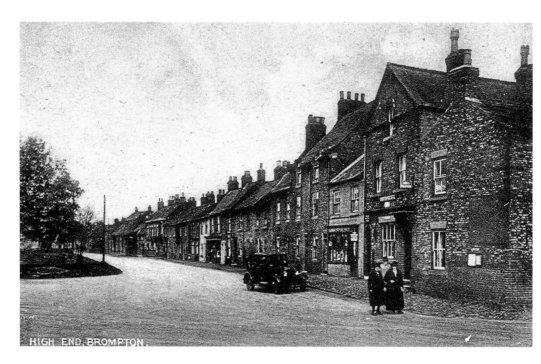

## Brompton High End

A 1930s photograph of High End with the village shop to the right and The Crown next to that. The Wesleyan Methodist Chapel was in High End – built 1817 and restored 1878. John Wesley preached here on some of his many visits to Osmotherley. Also there is the 1893 Chapel Sunday School and the homes of two of the Yeoman family, linen manufacturers and owners of Pattison Mill.

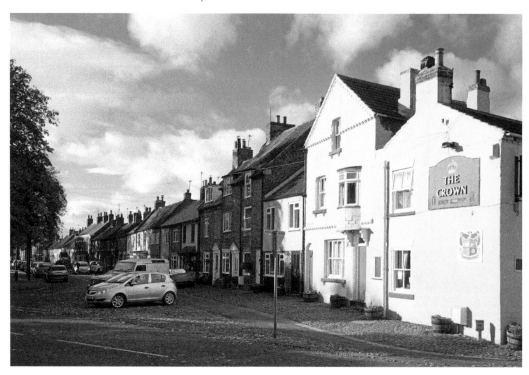

### The Church Hall

Built in 1875 the porch was added on in 1922; it was the venue for Sunday School and, in the winter, church services, on account of the warmth afforded by the coal stove – a luxury not available in the church.

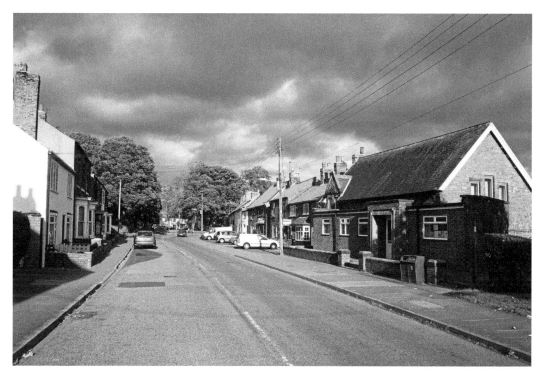

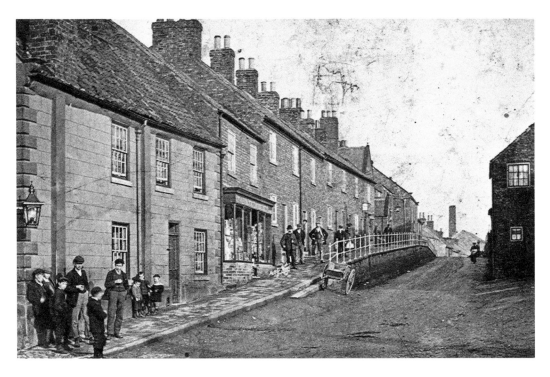

## Cockpit Hill

Cockpit Hill between High Green and Water End. The Three Horses pub is on the near left with the Co-operative store next to that. Oddfellows Hall is further up the hill with the chimney from Sherwood's corn mill in the distance.

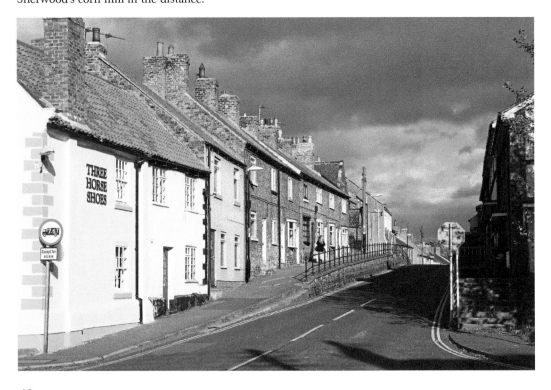

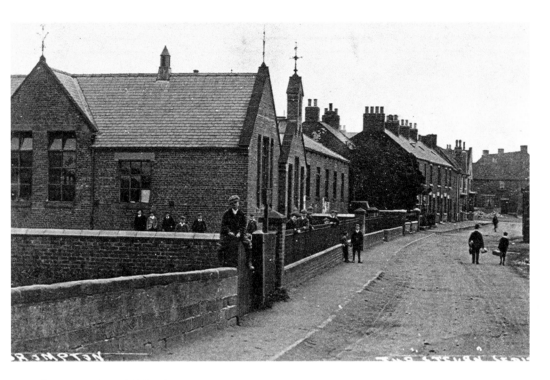

Brompton Board School

The first school in Brompton was opened in 1840; it became a Board School in 1870 and survived until 1974 when it was demolished and superseded by today's primary school, Brompton Community Primary School. Brompton's proximity to the site of the Battle of the Standard has led to nearby land being named Red Hills on account of the bloodshed.

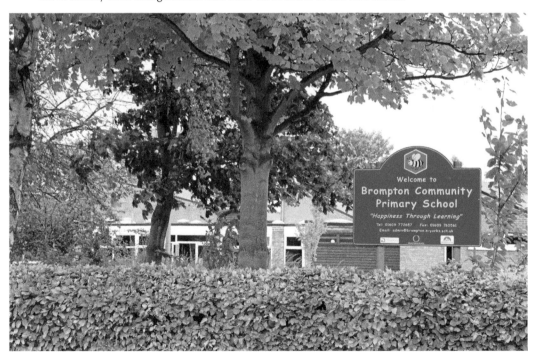

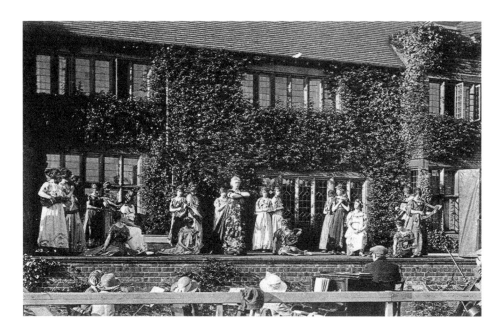

*Patience*

A performance of Gilbert and Sullivan's *Patience* performed in the 1920s outside The Close. The village was an important centre for linen making and weaving in the nineteenth century with eight mills in the village at its peak in 1820 but declined by the early twentieth century. St Thomas' Church in Brompton has the largest collection of hogback sculptures in the United Kingdom. This collection of hogbacks and Viking period crosses may suggest that Brompton was the location of a company of stone carvers during that period. Hogbacks are stone carved Anglo-Scandinavian sculptures from the tenth-twelfth century used as grave markers. It is thought that the hogback may have been invented in the area since the specimens here are amongst the oldest examples. The clock in the tower is always 10 minutes fast.

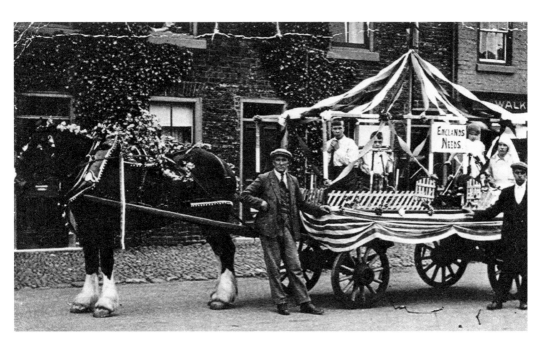

### Whitsuntide Sports

The Brompton Whitsuntide Sports reach back to time immemorial; this magnificent float dates from a relatively recent 1928; it won the famous Masterman Cottage Challenge Cup – a trophy instigated in the early 1900s by Mrs C. M. Masterman – wife of a local landowner – and is still presented today. Brompton has an online war memorial; it is claimed that this is the world's first interactive war memorial. It lists thirty-four fallen in the First World War and seven in the Second World War.

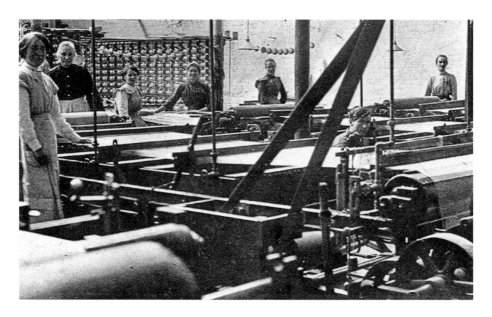

## Loom Minders at Brompton Mills

Linen production in Brompton started in the 1750s as a cottage industry; the arrival of the railways facilitated transportation of raw materials and finished products and led to its industrialisation and the establishment of the Pattison Yeoman and Wilford Mills 100 years later. The steam-powered looms were driven by water from Willow Beck which flows directly under the Pattison Yeoman engine room. Brompton turned out three types of linen: sheeting, huckaback towelling and heavy suiting. This intriguing photograph from 1910 shows lady loom minders and a male supervisor at work. Their day extended from 6.00 am to 5.00 pm. Exports included tropical uniforms for the Army in India; Brompton linen was exhibited at the Great Exhibition and the Paris Exhibition. Children left school at twelve years of age to work in the mills.

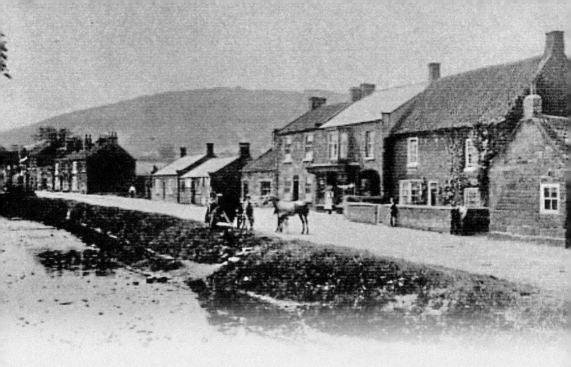

# Around Northallerton

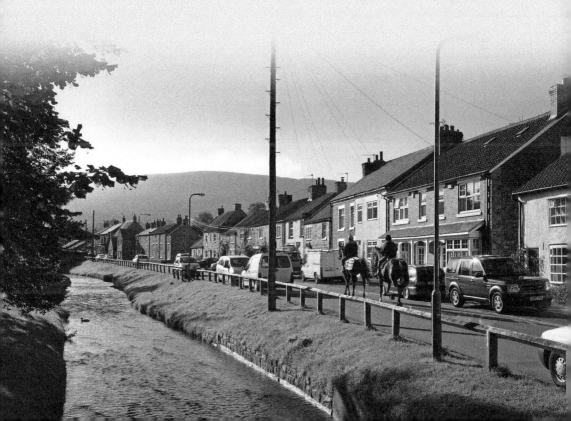

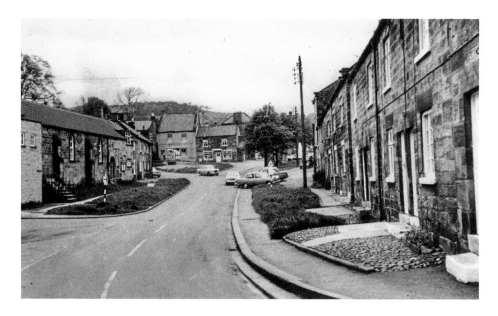

Osmotherley

A 1960s view looking towards the Market Cross. Originally Osmunderly from the Old Norse meaning Osmund's Ley and Asmundrelac – Asmund's clearing in *Domesday*. The 5-pillared stone barter table next to the cross was originally a market stall and used by John Wesley as a pulpit; he visited the village no less than 16 times. One of the first Methodist chapels in England was built here in 1754. An alternative derivation of the name comes from the legend whereby a soothsayer fortold the death by drowning of King Oswald's son, Oswy. To prevent this his distraught mother took him up Roseberry Topping but she fell asleep and Oswy fell into a pool watered by a spring and drowned. She buried him at a place called Teviotdale which took the name *Os – by his – mother-lay* when she died and was buried next to him. The public toilets on the left here next to the Church Hall have been voted the best in the UK on several occasions and are filled with flowers and decorated with pictures of horses.

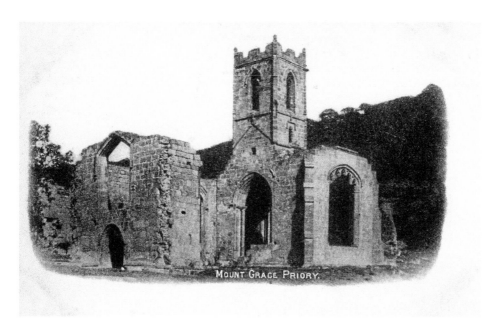

MOUNT GRACE PRIORY.

## The House of the Assumption of the Most Blessed Virgin and St Nicholas of Mount Grace in Ingleby

The best preserved of the nine surviving Carthusian monasteries or charterhouses. Thomas de Holland, Duke of Surrey, founded the priory in 1396; he was beheaded when his part in a plot to assassinate Henry IV in 1400 was discovered; his head was impaled on Tower Bridge and in 1412 his remains were reburied here. Twenty-one Carthusian monks lived as hermits in their own *en suite* 27 feet square cells with walled gardens, only coming together for certain services. It was a silent order of course and the monks wore hair vests. After Henry VIII's dissolution in 1540 the monastery was valued at £382. 5*s*. 11*d* and the tower bell was removed to All Saint's Northallerton where it tolls to this day.

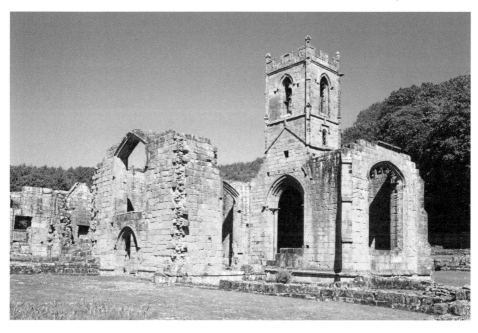

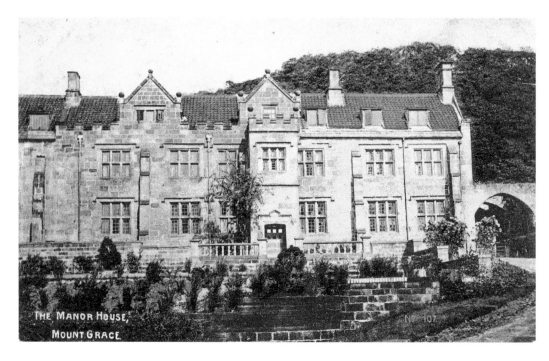

**Manor House, Mount Grace**

After the dissolution, the ruins of the guest-house of the priory were incorporated into two later houses: a seventeenth-century manor built by Thomas Lascelles and the larger house of the 1900/1 pictured here around 1908, an example of Arts and Crafts architecture. Visitors today can see the monastery, a reconstructed monk's cell, and the typically small Carthusian chapel and the house. There is also a museum on the site giving the history of the priory.

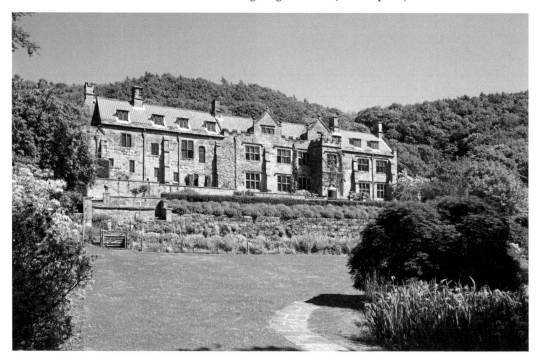

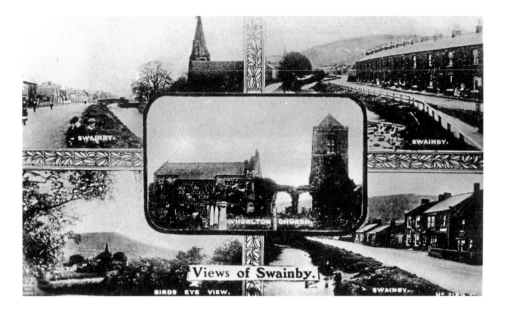

Views of Swainby.

## Swainby in 1921

This 1877 church (top left) replaces the original Norman church of the same name which was at Whorlton (centre). Swainby is named after the swains who worked on the estate farms of West Laithes and West Leeths and who lived here. Swainby first appears in records in 1368 and its settlement may be due to the Black Death driving the ten surviving inhabitants down the hill from Whorlton in 1428. Ironstone and jet mining in the mid 1800s led to some local prosperity and a surge in population. Some of these cottages (top right) go back as far as 1718. Nearby Scugdale was the birthplace of Elizabeth Harland who died in 1812 age 105 and of Henry Cooper a giant who grew to 8ft 6ins. The contemporary *1890 North Riding Directory* tells us *"this remarkable sample of humanity grew 13 inches in the space of 5 months."* He went to London and joined Barnum & Bailey's circus touring the USA with them. He returned to England sporting the name Sir Henry Alexander Cooper but died age thirty-two.

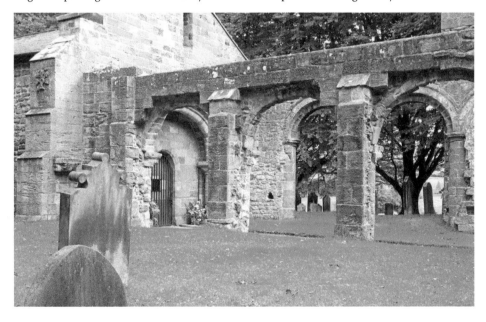

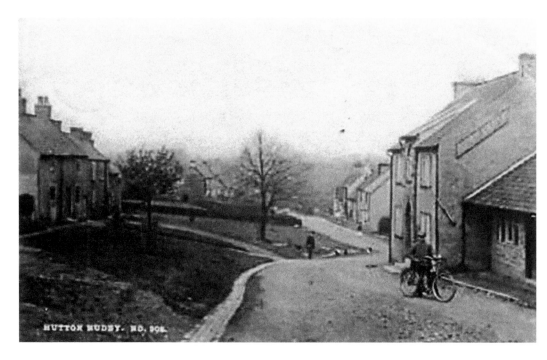

## Hutton Rudby and the Cow House

Robert Barlow, vicar here from 1831-1878 described the church as a cow house when he first saw it – and promptly set about improving it with the help of Lord Falkland, his patron. Robert Barlow, however, is best remembered for the unstinting and unselfish help he gave to cholera victims during an outbreak around 1832 when everyone else had fled the village. Hutton Rudby was at one time two villages: one called Hutton-juxta-Rudby, the other, on the other side of the Leven, Rudby.

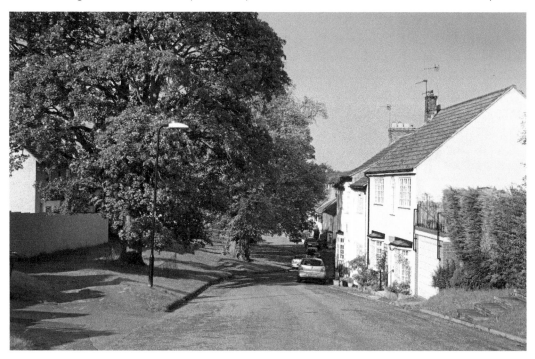

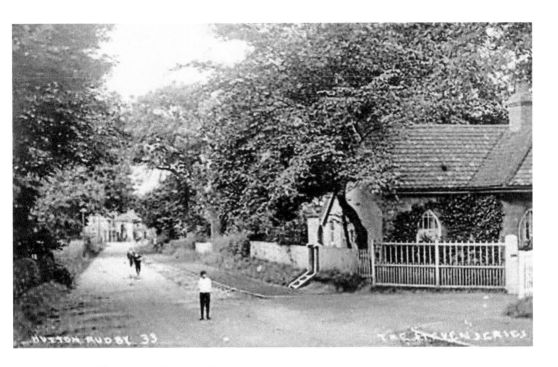

## Hutton Rudby and the Russian Navy

Life here goes back to the Stone Age, as evidenced by the barrow excavated at Folly Hill. Linen was the chief industry in the nineteenth century with twenty-three weavers appearing in the 1831 census when the population was around 1,000. Industrialisation came with the building of a mill and the cultivation of flax near to the River Leven which also was used to bleach and dry the cloth; the mill closed in 1908 but not before sailcloth took over as the main product – customers included the Russian Navy in 1870. Paper had been another industry, dependent on rags from the linen manufacturing.

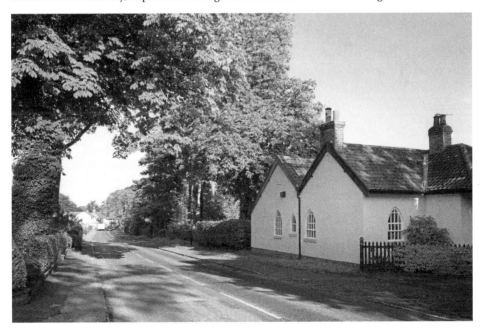

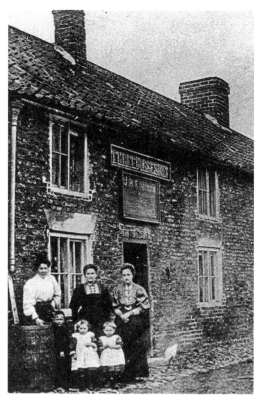

**The Three Horse Shoes, Deighton**
A picture from around 1910 showing villagers outside Joseph Robinson's Three Horse Shoes public house – now a private house. Robert Simpson, the previous landlord, was a blacksmith – his shop and forge have long been demolished. The remnants of a moat to the west of the village mark the existence of a fortified manor house, again demolished.

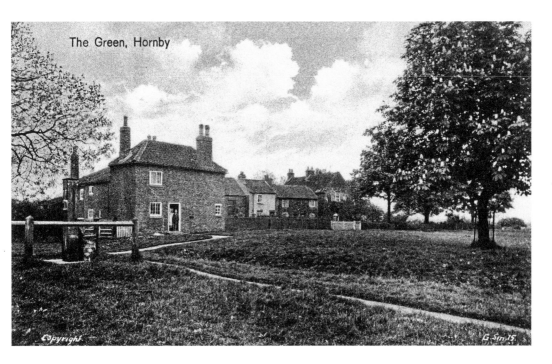

The Green, Hornby

### The Green, Hornby

Hornby, five miles north west of Bedale, has as its most famous son Bishop Tunstall born about 1474. Educated at Oxford, Cambridge, and at Padua he was considered the best mathematician of his day. He was made Bishop of London in 1522, keeper of the Privy Seal in 1523 and in 1530 was appointed to the bishopric of Durham. He was imprisoned in the Tower in 1551 for his opposition to protestantism, was reprieved upon Mary I's succesion, but was re-imprisoned by Elizabeth I and died in 1559 .

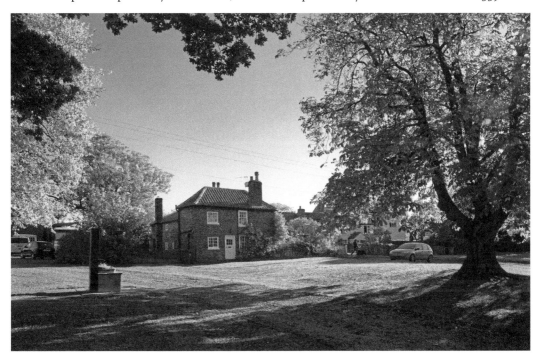

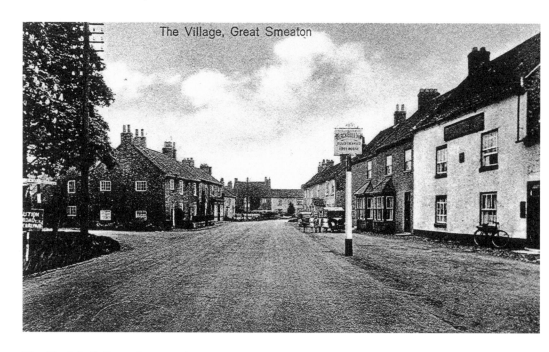

The Village, Great Smeaton

## The Black Bull, Great Smeaton in 1920

Formerly on the Great North Road The Black Bull would have been a busy stopping place before the railways – and the A1 – came. Up to twelve stagecoaches passed through each day and the horses would have been changed, fed and watered here. To cater for this trade the village had two other inns – the others being The Golden Lion and The Bay Horse. Like The Black Bull The Bay Horse survives today. The name Great Smeaton is probably derived from the Anglo-Saxon *Smideton* meaning the smith's farm.

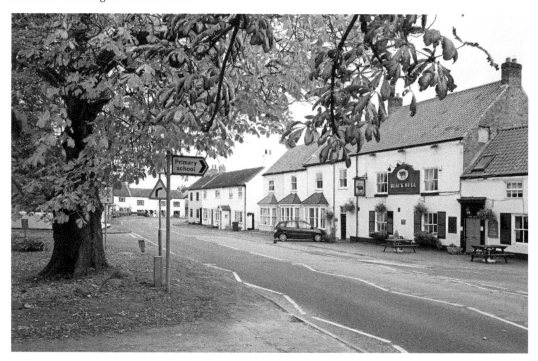

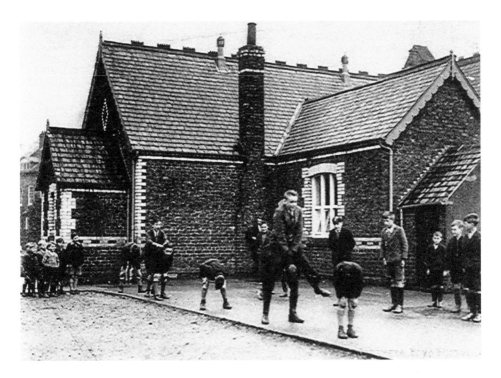

## Leap Frog!

A 1932 game of leap frog in the (boys'?) yard at Great Smeaton school built in 1874; now a private house occupies the site. At the time there were forty or so pupils – twenty boys and twenty girls. The Head, W. G. Bennett, is standing conspicuously at the foot of the chimney. Great Smeaton Community Primary School now educates the local children. St. Eloy's church here stands on the site of an eleventh-century Saxon church.

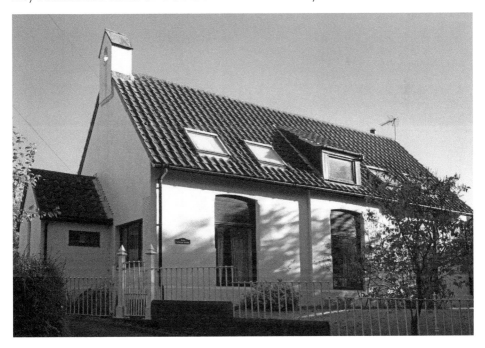

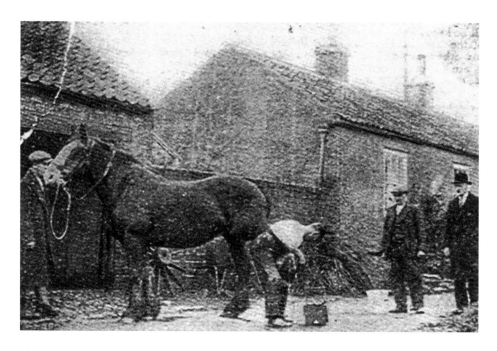

## The Blacksmith in Great Smeaton

Blacksmith Jack Fawcett is shown here shoeing a horse in the 1930s while Laurie Walker steadies its head. Blacksmiths often acted as hoopers, as the wheel behind the horse indicates. The church here, St Eloy's, is the only one in the country to be named after this particular saint, the seventh-century patron of goldsmiths and coin collectors, and of the British Army's REME corps, horses and horse workers.

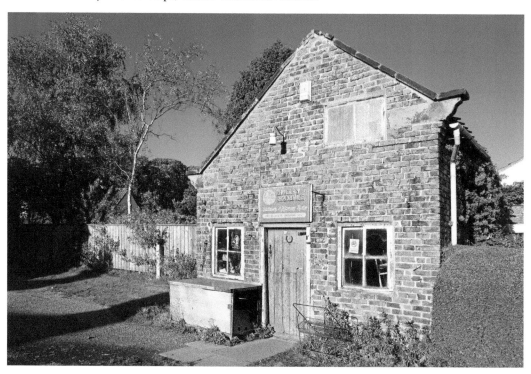

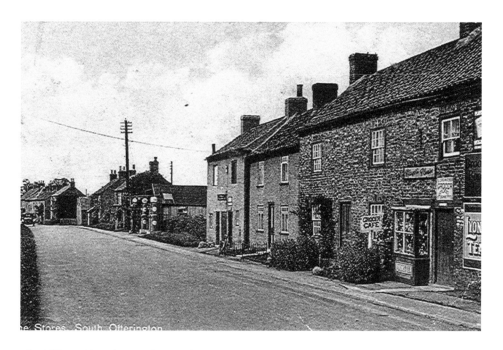

### The Village Shop in South Otterington

The village shop in the early 1930s with advertising for Player's cigarettes, Lyons tea and Brooke Bond tea. The shop also served as a café, as the sign indicates. The village is linked to Newby Wiske by a bridge. Former industries included a brickyard, a windmill and two mills.    The local pub is The Otterington Shorthorn – named after the breed of sheep familiar in the area.

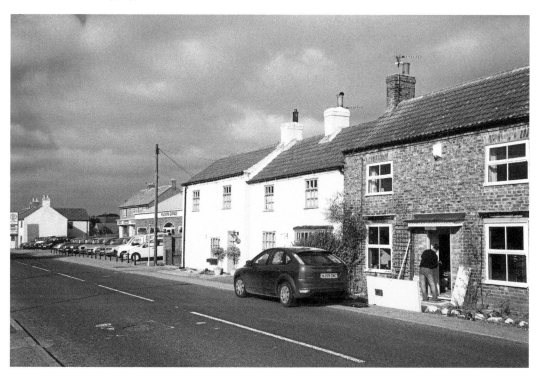

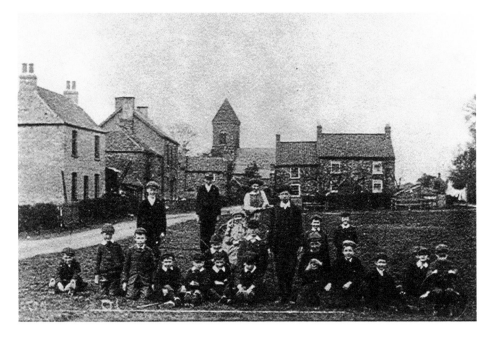

### South Otterington Public Elementary School for Boys

An early 1900s shot of a class on the green at Little Otterington. The school opened in 1863 but closed and the pupils then went to the mixed school at Newby Wiske. St Andrew's church can be seen in the background, built in 1846 and financed by William Rutson of Newby Wiske Hall. The church is famous for the violin cello accompaniment during hymns. Henry Rutson, the founder of the Rutson Hospital in Northallerton was one of his sons.

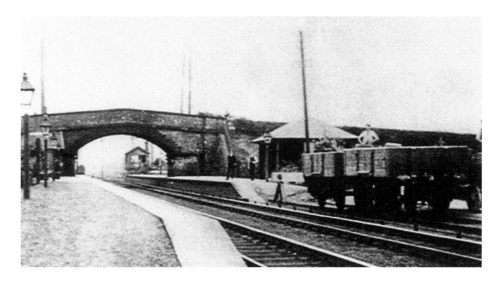

Otterington Railway Disaster

The 1841 station in the 1920s when it was on the main Darlington-York line.  Otterington is notorious for the dreadful accident which occurred there on 2 November 1892. Ten people died and Holmes was found guilty at York Assizes of manslaughter. The day before the crash, Holmes' baby daughter Rose was taken ill and  died. Holmes was  of course in a state of some distress  and had been awake for 36 hours walking miles to find  the local doctor who was out another call. He reported sick to the station master  but no relief signalman was appointed. About three hours into Holmes's shift, two Edinburgh-King's X express passenger trains approached  from the north; the second had been delayed and a goods train was sent down the main line. Holmes was "overmastered by sleep" and the goods train stopped outside his signal box. Holmes awoke, rather confused,  and accepted the second express which crashed at 60 mph into the goods train: hot coals from the firebox of the engine of the express train set the wreckage on fire – two of the bodies were incinerated and were never recovered. Holmes was given an absolute discharge in view of the extenuating circumstances. The railway was criticised for its cavalier treatment of Holmes.

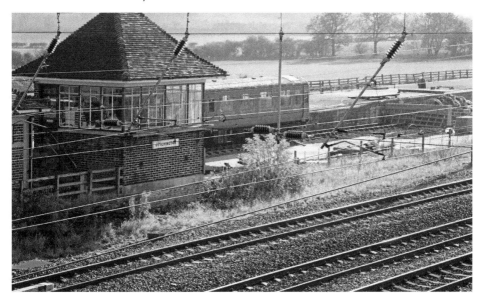

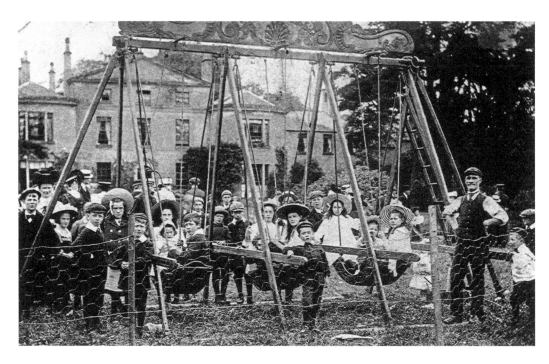

### Kirkby Wiske Show at Sion Hill

We meet the enterprising Frank Hardisty again (see page 40) this time proudly supervising the swings at the show outside Sion Hill mansion. Apparently, he used to sleep outside next to his swings during the various local shows he attended. Note the smart turn out of the boys and girls and the fashionable hats they are all wearing. Neo-Georgian Sion Hill was one of the last Edwardian country houses to be built in Yorkshire before the First World War. It was designed in 1913 by Walter H. Brierley of York, 'the Lutyens of the North'. The collection of antiques and works of art was started by Herbert W. Mawer Esq. in the 1930s and is continued today by Michael Mallaby Esq.

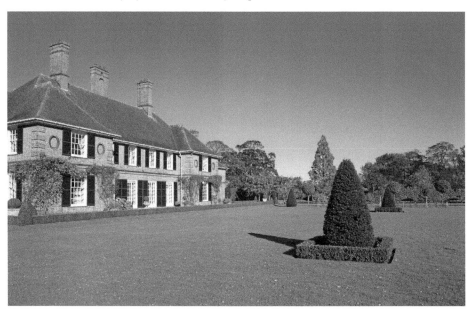

CHAPTER 9

# Bedale and Masham

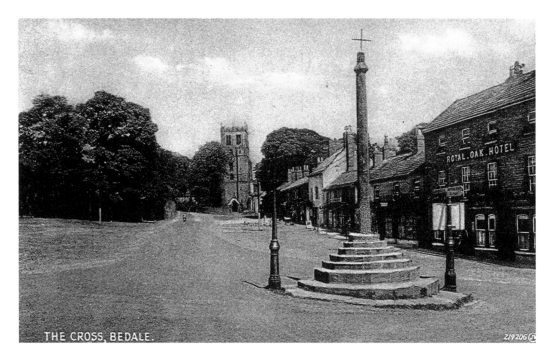

THE CROSS, BEDALE.

**Bedale Cross**

A fine 1905 picture of three of Bedale's most important structures: the Market Cross, The Royal Oak Hotel and St Gregory's Parish Church. The rector at the time went by the splendid name of Revd Windham de la Poer Beresford-Peirse MA. A less complicated William Pickersgill was landlord of The Royal Oak. The church has Saxon origins and has one of the country's best examples of a fortified tower. A scene from *The Way to the Stars* was shot just here.

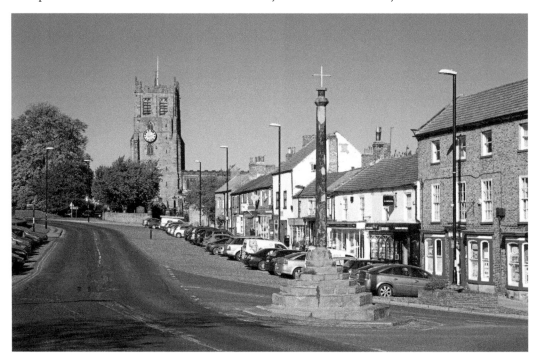

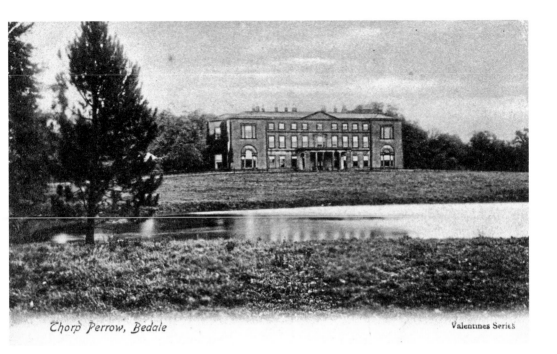

Thorp Perrow, Bedale      Valentines Series

### Thorp Perrow, Bedale

This 85-acre arboretum is one of the best private collections of trees and shrubs in the country. It is unique to Europe, in that it was the creation of one man, Colonel Sir Leonard Ropner (1895–1977) and is still in the family, managed by Sir John Ropner. The Arboretum also includes the Milbank Pinetum planted by Lady Augusta Milbank in the mid nineteenth century, and the mediaeval Spring Wood dates back to the sixteenth century. There is also a Bird of Prey and Mammal Centre here. Note the fly fisher in the new picture.

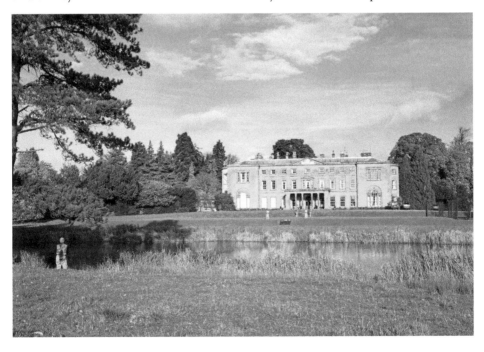

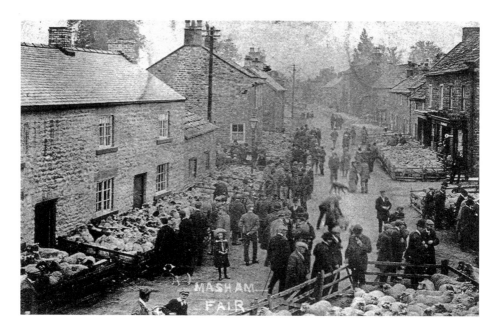

### Masham Sheep Fair

Masham is derived from the Anglo-Saxon *Mæssa's Ham*, the homestead of Mæssa. Around 900 AD the Vikings devastated the church and town; they also introduced sheep farming for which the town is still well known today: Masham's standing as a major sheep market explains the huge market place and its fine Georgian houses. The town can boast one of the oldest markets in the UK, receiving its first charter in 1250. The market originally thrived because of its proximity to Jervaulx and Fountains Abbeys, with the large flocks of sheep kept by the monks. The annual Sheep Fair is in September; the modern photograph by Rick Harrison shows a camera-shy contestant in the 2010 event.

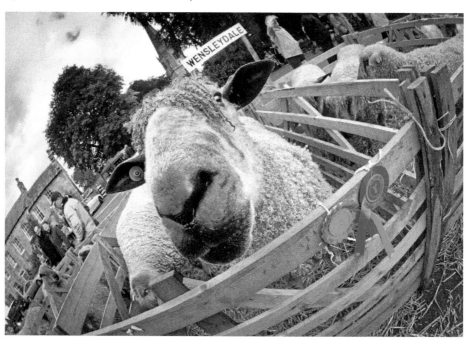

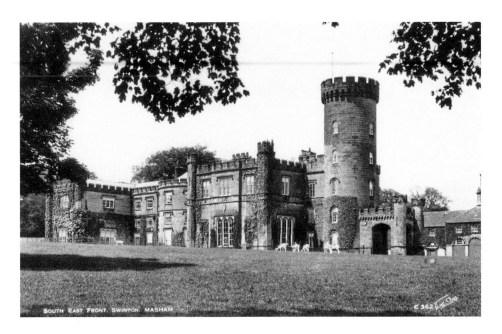

SOUTH EAST FRONT, SWINTON, MASHAM

## Swinton Park and the Coffin Pond

The ancestral home of the Cunliffe-Lister family set in 200 acres of parkland, lakes and gardens. The castle is surrounded by the family estate. The earliest record of a garden here is one designed and established in 1699 by George London, complete with fountains. This was superseded by William Danby's garden in the 1760s; around the same time the lakes were designed and dug out. During the early 1800s the stone bridge at Coffin Pond was built, and the stone coffins, dug up in a nearby quarry, were laid out beside the boathouse. They are thought to date from the late Saxon period, and that they were coffins for the nuns in the local nunnery. Samuel Cunliffe-Lister bought the park in 1880 with the fortune he made from his Bradford woollen mills. The four-acre Walled Garden has recently been restored by Susan Cunliffe-Lister.

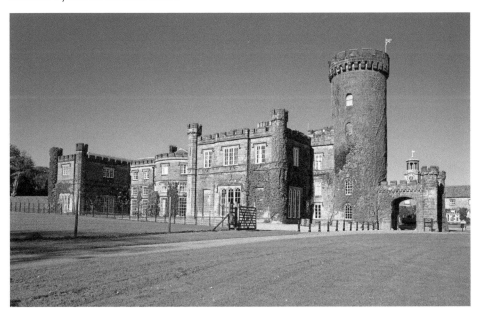

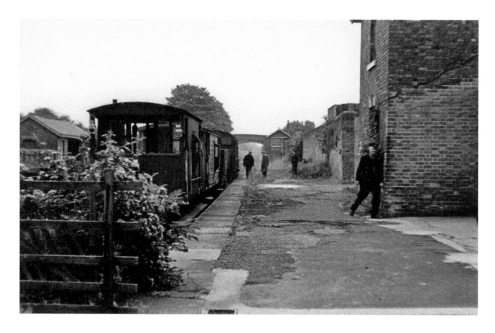

### The Old Station, Masham

Today the old station is occupied by the Old Station Yard Caravan and Camping Park. You can still see the Masham station platform sign to the right; the new reception and café pictured here bears a "Goods Shed" sign. The station marked the terminus of a 7½-mile branch from Melmerby on the Leeds Northern route from Harrogate through Ripon to Northallerton on the East Coast main line. It opened in 1875: traffic was mainly agricultural, coal and gravel, with six return passenger trips daily to Ripon. In both World Wars nearby military installations and ammunition dumps made frequent use of the line. It closed to passenger traffic in 1931 and to goods in 1963.

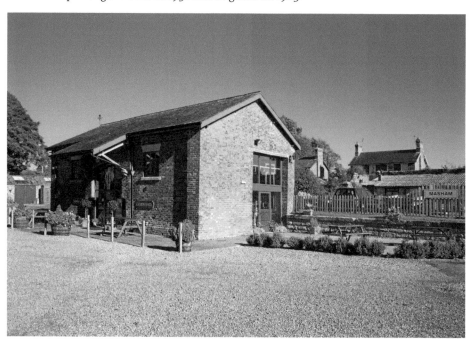

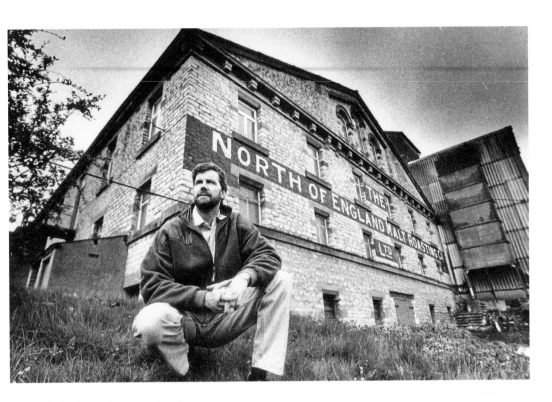

### Black Sheep Brewery, Masham

What better place to end than at a brewery! The Black Sheep Brewery grew out of Paul Theakston's ambition to create a new but traditional style brewery in Masham after the six generation family firm of T. & R. Theakston's was bought by Matthew Brown and then Scottish & Newcastle Breweries in 1987. Paul bought the North Yorkshire Maltings Company, originally part of the former Lightfoot's brewery site, from an animal feed company.

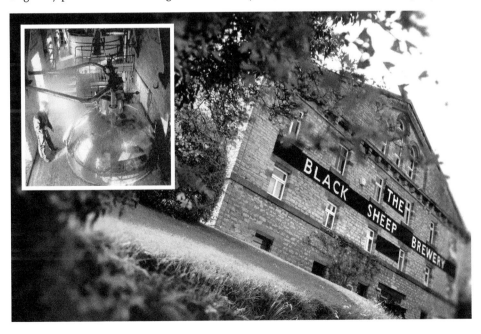

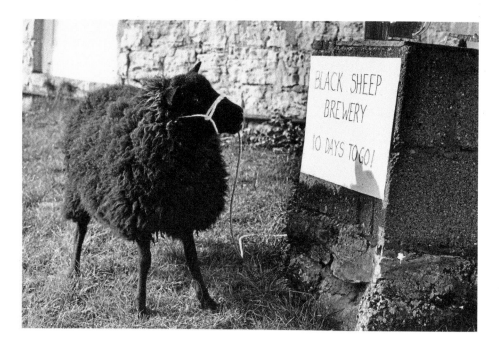

## Riggwelted in Masham

October 1992 first saw Black Sheep beers served in pubs in and around the Yorkshire Dales. *Riggwelter* is one of their popular beers and takes its name from the dialect words for a sheep which is on its back and struggling to get up – riggwelted. This in turn is derived from the old Viking words for *rigg* meaning back and *velte* to overturn. *Riggwelter* is also popular in Sweden, being in the top twenty of bottled ales sold there. The brewery now produces over 75,000 barrels a year. Today Black Sheep has a thriving Visitor Centre which, among other things, hosts brewery tours...and tastings. Cheers!